SHiRTLESS!

THE HOLLYWOOD MALE PHYSIQUE

BY DONALD F. REUTER

UNIVERSE PUBLISHING

This book is for Jeff S., Jim H., and Tyrone E., three hand-some men with whom I spent many a sweaty day (and night) in hot pursuit of the beautiful male chest—on others *and* ourselves. We found it—quite often—but I miss the search.

cover: TAB HUNTER (see page 50) Today, Hunter would look just as inviting poolside as he did here almost fifty years ago. (*Kobal*) *front endpaper:* CLINT EASTWOOD (see page 83). (*Michael Ochs*) *opener:* SAL MINEO (*b.* January 10, 1939, Bronx, New York. *d.* 1976.) Mineo's life was laden with misfortune—including his own horrific homicide. Despite typecasting, Mineo won two supporting actor Oscar nominations for *Rebel without a Cause* (1955) and *Exodus* (1960). (*Corbis*) *title page:* JOHNATHAN SCHAECH (*b.* September 10, 1969, Edgewood, New Jersey.) This star of *That Thing You Do* (1997) and *Houdini* has a body so beautiful no words can express the vision. (*Staedler/Corbis-Outline*) *this spread:* JOHN PAYNE (*b.* May 23, 1912, Roanoke, Virginia. *d.* 1987.) Even in the thirties, when this shot was taken, Payne had the kind of body that could not be overlooked. But try to in *Kid Nightingale* (1939). (*Kobal*)

First published in the United States of America in 2000
by UNIVERSE PUBLISHING
A Division of Rizzoli International Publications, Inc.
300 Park Avenue South
New York, New York 10010

© 2000 Donald F. Reuter

Designed by Donald F. Reuter

Printed in Singapore

2001 2002 2003 2004 2005
10 9 8 7 6 5 4 3 2 1

Library of Congress Cataloging-in-Publication Data

Reuter, Donald F.
 Shirtless : the Hollywood male physique / Donald F. Reuter
 p. cm.
 Includes index.
 ISBN: 0-7893-0508-9
 1. Motion picture actors and actresses--United States--Portraits.
 2. Male actors--United States--Portraits. I. Title.

PN1998.2 .R48 2000
791.43′028′0810973--dc21
 00-057772

All items credited to Author's collection (or AC) do not constitute ownership of actual images presented therein and are reprinted for illustrative purposes only. Images credited to MPTV on pages 83 and 152 (bottom center) were photographed by Gunther; page 156 by John Jay; page 88 by Eric Skipsey; pages 11, 110, 111, 124, 126 (top right), 127, and 149 (top center) by Gene Trindl.

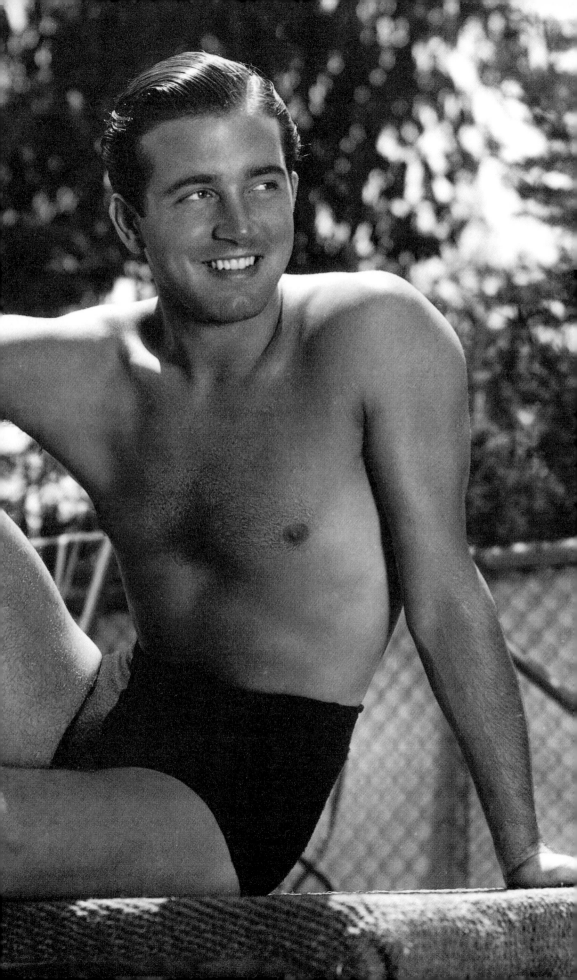

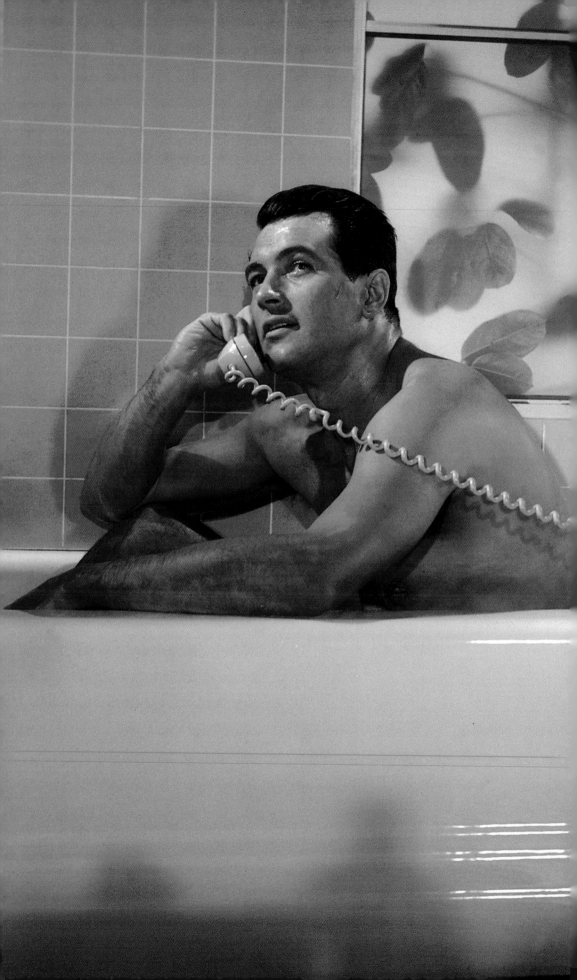

iNTRODUCTiON:
GENTLEMEN, NO SHIRTS ALLOWED 8

iN THE BEGiNNiNG:
WHEN SILENCE WAS GOLDEN (AND TANNED) 12

THE THiRTiES:
DAPPER DUDES AND RANDY RUFFIANS 18

THE FORTiES:
HERE HE COMES TO SAVE THE DAY! 30

THE FiFTiES:
SEPARATING THE MEN FROM THE BOYS 40

THE SiXTiES:
GORGEOUS GUYS A-GO-GO 70

THE SEVENTiES:
SLIM, SEXY, AND SO-O-O-O AVAILABLE 94

THE EiGHTiES:
INVASION OF THE BODY SMASHERS 116

THE NiNETiES AND BEYOND:
MUSCLED MALE MAGNIFICENCE 134

MAN TO MAN:
A BEEFY FEAST 146

iNDEX:
A HARD MAN IS EASY TO FIND 156

ACKNOWLEDGMENTS:
BEHIND EVERY MAN . . . 158

this spread: ROCK HUDSON (b. Roy Harold Scherer Jr., November 17, 1925, Winnetka, Illinois. d. 1985.) Though all six-foot-four of Hudson was a star, he attracted fans with his wholesome manner instead of using his imposing physique to intimidate. This is a shot of Hudson at his gregarious and gorgeous best—wet and waiting for action in the tub—from *Pillow Talk* (1959), one of his many popular bedroom farces. A body just doesn't get any better than this. (*Corbis*)

INTRODUCTION:
GENTLEMEN, NO SHIRTS ALLOWED

While researching photographs for an earlier work, *Heartthrob*, I had the good fortune to come across a number of images of many favorite male stars barechested (often even more unclothed). It occurred to me that I had not seen these pictures in print. I found it curious in an age when most male stars readily show off their primed physiques that a collective presentation of these gentlemen had not been undertaken. How lucky for me. But I did not embark on this project for purely prurient reasons (although, what's wrong with that?). I firmly feel that the form of the male body—most especially the Hollywood versions—is shaped by the times in which it exists. More succinctly put: big pecs and washboard abs happen for a reason.

However, there is nothing new about the sight of a barechested man on film (or even a well-developed male physique); it's an occurrence as old as the medium itself. Why? Because for the most part until recently the sight of a man's body was not regarded in the same highly sexualized context that it was for women, so it was not *seen* as troublesome. But, as I hope you will *see* once you come to the conclusion of *Shirtless!* is that the frequency in which male barechestedness happens, the amount of male skin we are shown, and the definition of the male body easily reflect the general mores of the day. Before we venture on, I use these three examples to illustrate my points:

1 Well-respected actor James Stewart is shown barechested in the classic film *Rear Window* (1954). But, his body lacks any semblance of the kind of pleasing muscular development we are used to seeing on today's male stars. Granted, he was in his mid-forties, but would any current middle-aged star allow himself to look this way? I think not. Nevertheless, Stewart was an enormous box office draw at the time and the shape of his body, while obviously not the focus, was handled with an alarming amount of passivity.

2 While seeing a major male star *sans* shirt was nothing new, going *beyond* shirtless was a very rare occurrence. It would not be until the late sixties, when total male nudity would be reintroduced (male nudity was present in pre-Code Hollywood films) to anxious viewers in mainstream works. One example to mark this moment is a glimpse, on pages 92–93, of one of filmdom's most perfect posteriors—on Leonard Whiting (from 1968's *Romeo and Juliet*).

3 Cut to present day. Bright, young actor Chris Klein, barely into his twenties, has an affable manner already being compared with that of James Stewart. But, he has a body that appears godlike in comparison. I know, it's not fair to compare the two agewise, but Klein's quick rise to stardom has a lot to do with his good looks and superb body. This is, no doubt, influenced by today's emphasis on physical fitness.

far left, opposite: **GEOFFREY HORNE** (b. August 22, 1933, Buenos Aires) on location while filming *The Bridge on the River Kwai* (1957). Horne

never made it out of the bull pen as a film star but still made quite an impression with his boy-next-door looks and trim body. (*Corbis*) *above:* **GEORGE O'BRiEN** (see page 16) on the cover of *Physical Culture* magazine (1938). (*AC*) *left:* **GUY MADiSON** (see page 31) was a forties male version of the female pinup. Watch where you stick those pins, boys! (*Kobal*)

Before, an actor's physique would have played a less significant role in his career.

While you barely read through the text as you ogle the pictures, bear in mind that this book would also not have been publishable if not for the cultural advances of women, gays, and other factions of society within the last thirty-odd years. The careers of most of today's hottest (and I mean that in both the talent and bodily sense) male properties would not exist were it not for a general climate of permissiveness. The fact that I, along with so many other men (straight and gay) feel compelled to work out by virtue of the inescapable presence of these perfect male physiques everywhere we turn proves the influence of this revolution—but I'm not complaining!

In *Shirtless!*, I have broken down the past one hundred years into decades. This is not to say that change falls precisely along the turn of each decade. More often it follows (or precedes) political, social, or economic upheavals. It is, however, a diplomatic way to divide time. One thing does remain constant from decade to decade, political epoch to political epoch: while one type of body may be the dominant choice, there is always the presence of another to satisfy the predilections of those who do not follow the flow. So one always has the choice between hairy and smooth, big or slim.

Finally, I would like to mention that the content of *Shirtless!* reflects a certain amount of personal bias and, therefore, cannot be regarded as a comprehensive collection of all the best male bodies shown on the silver (and small) screen. I also deliberately chose to concentrate my efforts on showcasing male physiques prior to the eighties. Today, in a time when perfect male bodies are almost commonplace, I felt it important to focus on the men who paved the way for this bounty. Further, while it is common to see current male stars in varying degress of undress onscreen, they protect their images offscreen with an alarming amount of vigilance. This is, as it was in times past, an attempt to direct the public's gaze away from physical endowments toward a consideration of their acting skills. As if one could ever look at Brad Pitt and not see his body!

upper left: **CHRiSTOPHER ATKiNS** (*b.* February, 21, 1961, Rye, New York) made a huge splash in *The Blue Lagoon* (1980) but has not surfaced nearly enough lately. (*Corbis/LGI*) *left:* **GREGORY HARRiSON** (*b.* May 31, 1950, Avalon, California) is one of the hunkiest actors around. For pure indulgence, try to find a copy of the telefilm *For Ladies Only* (1981). Take it all off, Gregory! (*AC*) *right:* **RYAN O'NEAL** (*b.* April 20, 1941, Los Angeles) became famous via the daytime soap *Peyton Place*, then with his role in *Love Story* (1970). By the way, that is Tatum standing by her studly dad in this shot from a *Peyton Place* cast picnic. (*MPTV*)

iN THE BEGiNNiNG:

WHEN SILENCE WAS GOLDEN (AND TANNED)

Many of us tend to view things that are created "before our time" as hopelessly out of date with current fashion. But nothing would be further from the truth regarding silent film. Male-oriented movie genres—from boxing sagas, westerns, to action hero adventures—enjoyed popularity at the box office; motion pictures dealt with sex, sexuality, miscegenation, adultery, drug addiction, and more; and the male body was presented in ways far more scintillating than one would expect. Don't take my word for it. Look at this film still from *The Young Rajah* (1922), which clearly details just how up-front silent film could be. Movies had an air of maturity about them that can be attributed only to pre-Code permissiveness. The Code (see page 18) censored content in an attempt to assuage moralists (prior to this, content was regulated solely by individual producers). This set back the artistic advances that had been made thus far.

this spread: RUDOLPH VALENTINO (*b.* Rudolpho Alfonzo Raffaele Philibert Guglielmi, May 6, 1895, Castellaneta, Italy. *d.* 1926.) An early job as a taxi dancer helped Valentino cultivate the graceful movements and mannerisms that would become his screen hallmarks. Selected to play the lead in the smash *The Four Horsemen of the Apocalypse* (1921), beautiful Valentino became the idol to millions of women the world over. Interestingly, his dark good looks and muscular physique, while proving tonic for female moviegoers, were largely frowned upon by men. It would not be the first time that a beautiful male face and body would cause consternation among male moviegoers. (*Kobal*) *below:* DOUGLAS FAIRBANKS (*b.* Douglas Elton Ulman, May 23, 1883, Denver, Colorado. *d.* 1939.) Besides being one of the top male motion picture stars of all time, Fairbanks was also a well-established Broadway performer. His nonchalant attitude and physical grace, which won him fans on the Great White Way, also served him well as he ventured into a series of very popular action pictures—one of the most notable, *The Thief of Baghdad* (1924)—which made him the first formidable action hero. Forever tan and trim, Fairbanks was, at the time, considered the ideal American male. (*Kobal*)

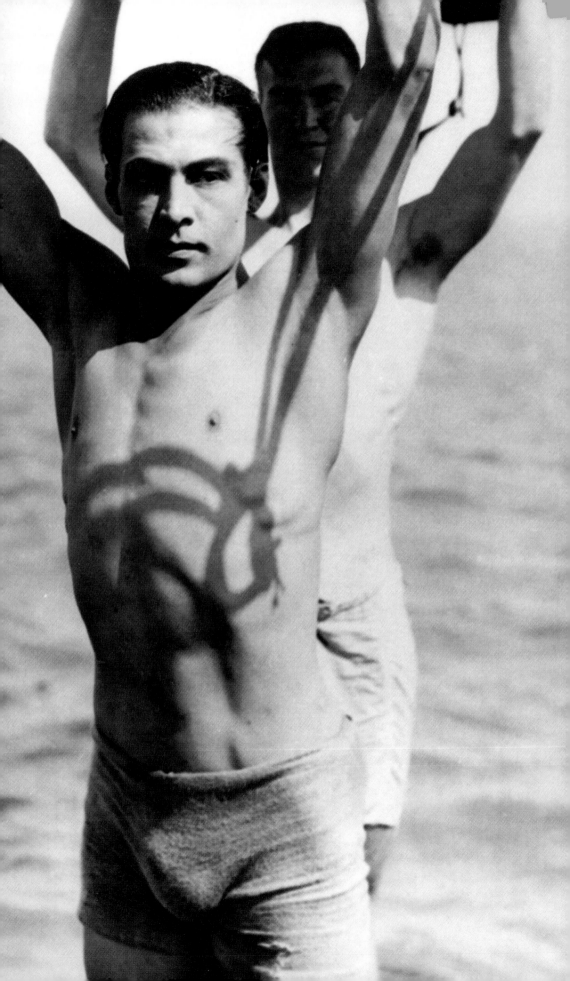

*T*he male body of silent-era stars was by and large rather unremarkable. For the most part, their physiques reflected the public's general lackadaisical attitude toward fitness. Even top stars, like Charles Farrell (*above*), were prone to have concave chests and very little, if any, definition. However, there were exceptions when Hollywood realized the box office potential of a beautiful body and sought to display it to its best advantage. Some of the best physiques of the day—including Valentino, O'Brien, and Fairbanks—would still look like prime cuts in today's meatier market.

inset: CHARLES FARRELL (*b.* August 9, 1901, Onset Bay, Massachusetts. *d.* 1990.) This humble hunk played bit parts and small roles until he hit paydirt as *the* romantic male lead opposite screen favorite Janet Gaynor. Though his career carried over into talkies, his handsome face and body were not enough to keep him in good stead with the moviegoing public. He retired from films in the early 1940s. Film still from *Old Ironsides* (1926). (*Kobal*) *this spread: JOHN BARRYMORE* (*b.* John Sidney Blythe, February 15, 1882, Philadelphia. *d.* 1942.) It is not often that you find a serious actor in such seriously good shape, but Barrymore was no ordinary fellow. Known as "the profile" for his remarkable good looks, this grandfather of actress Drew Barrymore was quite the catch before the ravages of alcoholism and a reckless life set in. This film still from *Tempest* (1928) shows he had quite a well-built teapot. (*Kobal*)

14

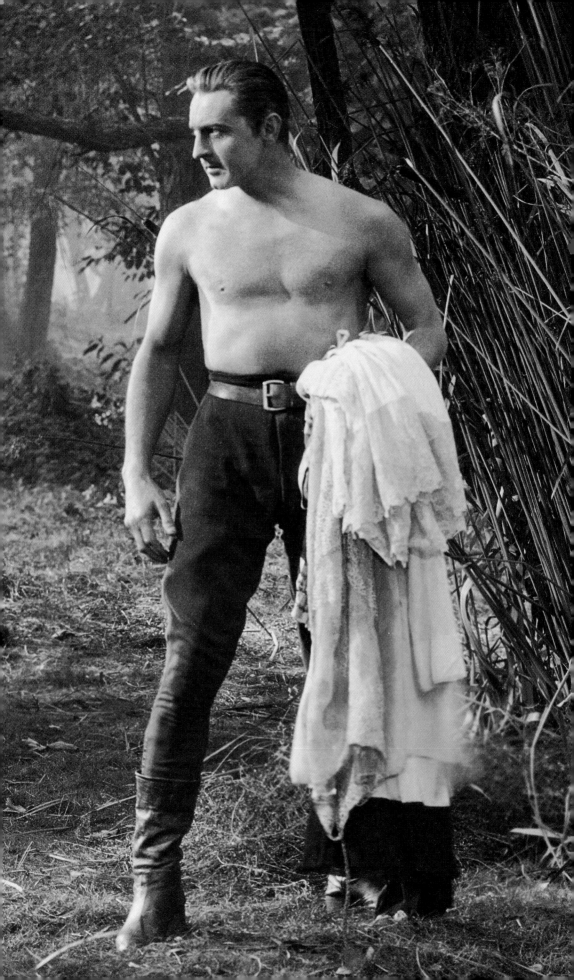

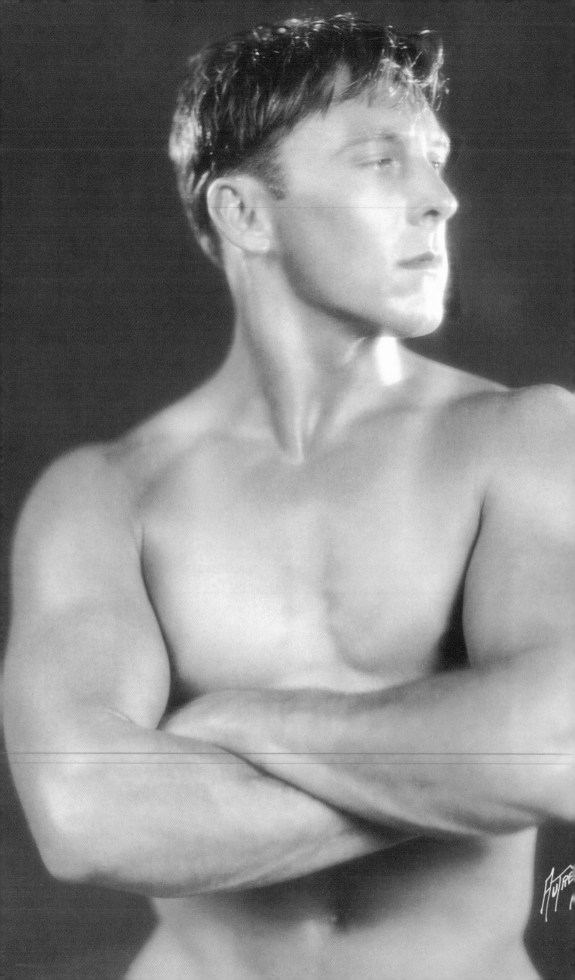

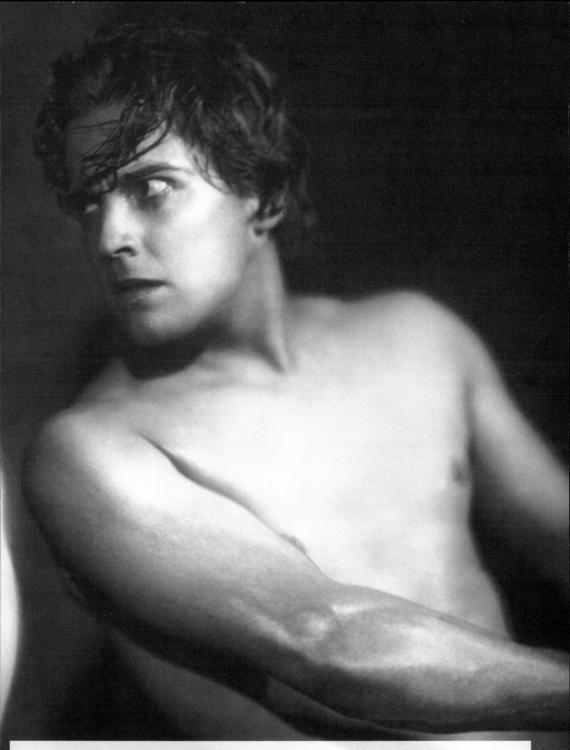

left: **GEORGE O'BRiEN** (*b.* April 19, 1900, San Francisco. *d.* 1985.) Born the son of the city's chief of police, George was truly Holly-wood's first perfect male physique. Though largely forgotten now, this onetime stuntman was also a boxing champion for the Pacific fleet during World War I before he entered into films in 1922. Once dubbed "the chest," this amazing male specimen was one of the few early male stars who was often "caught" with his shirt off. A real beauty. (*Kobal*)

this page: **RAMON NOVARRO** (*b.* Ramon Samaniegos, February 6, 1899, Durango, Mexico. *d.* 1968.) If Valentino had a screen rival it was Novarro. But while both enjoyed success as two of the screen's early "Latin lovers," Ramon broadened the range of his roles in an effort to stay solvent. His most famous film was *Ben-Hur* (1925) and like many of the pre-Code epics, the movie was filled with tantalizing snip-pets of the male body, including this shot where Ramon was a galley slave. Novarro's physique was also typical of the top male leads of the day; though not muscular in the modern sense, it did have a certain athletic trimness. (*Kobal*)

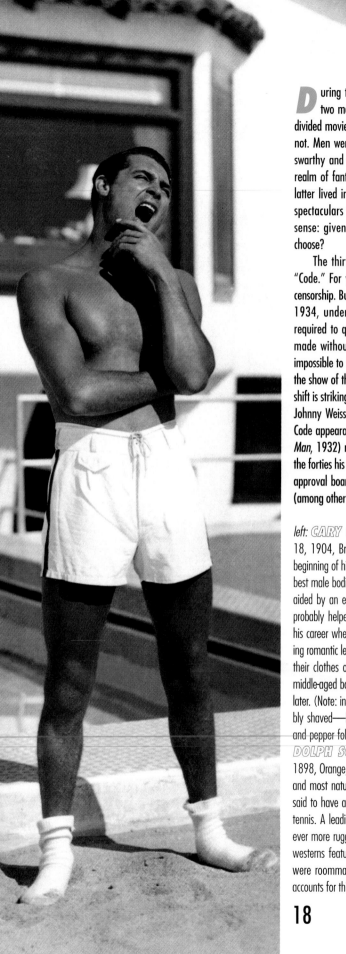

During the thirties the Hollywood male body split into two major types for the first time, and the depression divided movie content into those who had and those who had not. Men were either sleek and sophisticated gentry or the swarthy and sweaty working class. The former inhabited a realm of fantasy—swimming pools and sedans—while the latter lived in a world of harsh reality. That the deco-laden spectaculars were the more popular choice made perfect sense: given high times or hard labor, which would you choose?

The thirties also saw the instigation of the infamous "Code." For years, Hollywood had attempted self-imposed censorship. But this did not satisfy the conservative-minded. In 1934, under the direction of Joseph Breen, films were required to qualify for a seal of approval. (A film could be made without one, but the film would have been almost impossible to distribute.) At first glance, the effects this had on the show of the male body seemed slight. But in hindsight the shift is striking indeed. For instance, take the loincloth worn by Johnny Weissmuller in his run of *Tarzan* films. His first pre-Code appearance as the mighty jungle hero (*Tarzan, the Ape Man*, 1932) reveals a delectable amount of derriere, but by the forties his tight tush was under wraps. The consensus of the approval board was that this type of wanton display of flesh (among other things) led to a general degradation of society.

left: CARY GRANT (b. Archibald Alexander Leach, January, 18, 1904, Bristol, England. d. 1986.) Hands down, from the beginning of his film career to its end, Grant possessed one of the best male bodies on screen. No doubt his well-tanned visage was aided by an early start as a lifeguard and his work in musicals probably helped him to develop tone and musculature. Later in his career when most of his contemporaries were either eschewing romantic leads in favor of character parts, or (thankfully) kept their clothes on, Grant displayed an almost too-good-to-be-true middle-aged body that would not be equaled until many decades later. (Note: in the early days Grant's chest was hairless—probably shaved—but by the late fifties and into the sixties his salt and pepper follicles were in full groomed bloom.) *right:* RANDOLPH SCOTT (b. George Randolph Crane, January 23, 1898, Orange, Virginia. d. 1987.) Easily one of the handsomest and most naturally well-built men of his or any time, Scott was said to have acquired his body through running, swimming, and tennis. A leading star in the thirties, Scott aged well, becoming ever more rugged. This look was well suited to a series of fifties westerns featuring him as the "mature" hero. Scott and Grant were roommates for a long period during the thirties, which accounts for this "play time" publicity shot. (*Kobal*)

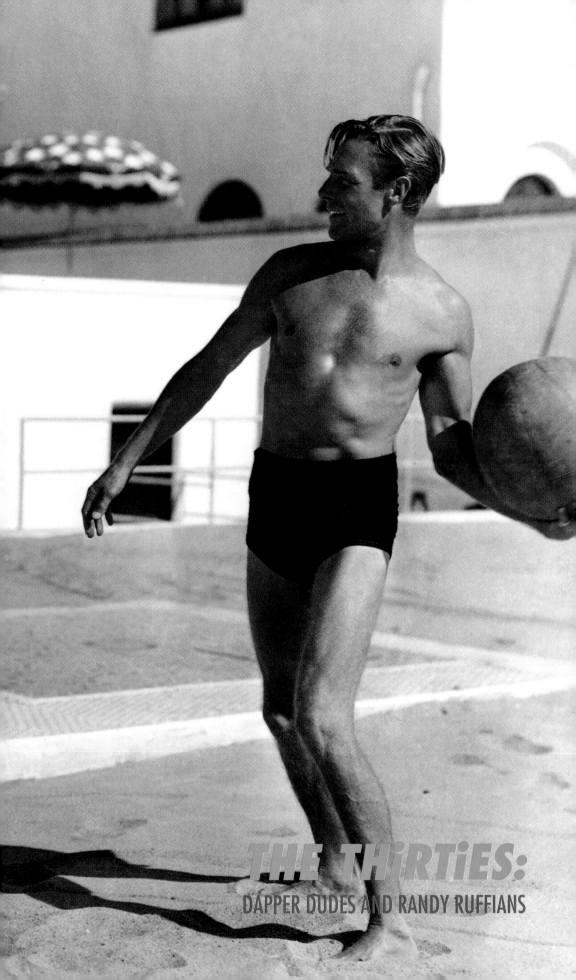

THE THIRTIES:
DAPPER DUDES AND RANDY RUFFIANS

Poolside with two of Tinseltown's finest-looking male protagonists—Douglas Fairbanks Jr. and John Gilbert. Notice, though both wear the latest in sun fashions, Fairbanks's navel is discreetly hidden. Watch for the lowering of the waistline—a telling indicator of body display permissiveness.

this spread: JOHN GILBERT (*b.* John Pringle, July 10, 1895, Logan, Utah. *d.* 1936.) The top romantic lead of the late silent era, Gilbert's career did manage to carry over into the age of sound—this still is from 1932—but the transition would prove his downfall. For years, his handsome face and body were thought the pinnacle of male attractiveness, but, whether it was his high-pitched voice or a relative disinterest in the type of films that made him popular, his descent was hastened by the advent of talkies. Most often remembered as the on- and offscreen paramour of legendary Greta Garbo—see *Flesh and the Devil* (silent, 1927) or *Queen Christina* (sound, 1933)—Gilbert also had a manageable amount of chest hair that balanced his omnipresent moustache. However, a hairy chest on a male star was, for the most part, the exception, not the rule. Hair connoted a quality of brutishness; while no hair

(or a clean-shaven set of pecs) was considered refined-looking. The vast majority of male stars, wanting to project an air of suave sophistication, opted for the smooth look. (*Kobal*) *below:* DOUGLAS FAIRBANKS JR. (*b.* December 9, 1909, New York City. *d.* 2000.) The gorgeous offspring of Fairbanks Sr. and his first wife Anna Beth Sully. Though he never attained the star billing afforded his father, Douglas made his mark as one of the most dashingly good-looking male stars of the thirties. An antidote to depression blues—see *The Young in Heart* (1938)—he was the epitome of grace and good breeding—his smooth, tanned, lightly muscled form so perfectly capturing the essence of a deco dandy. (*Kobal*)

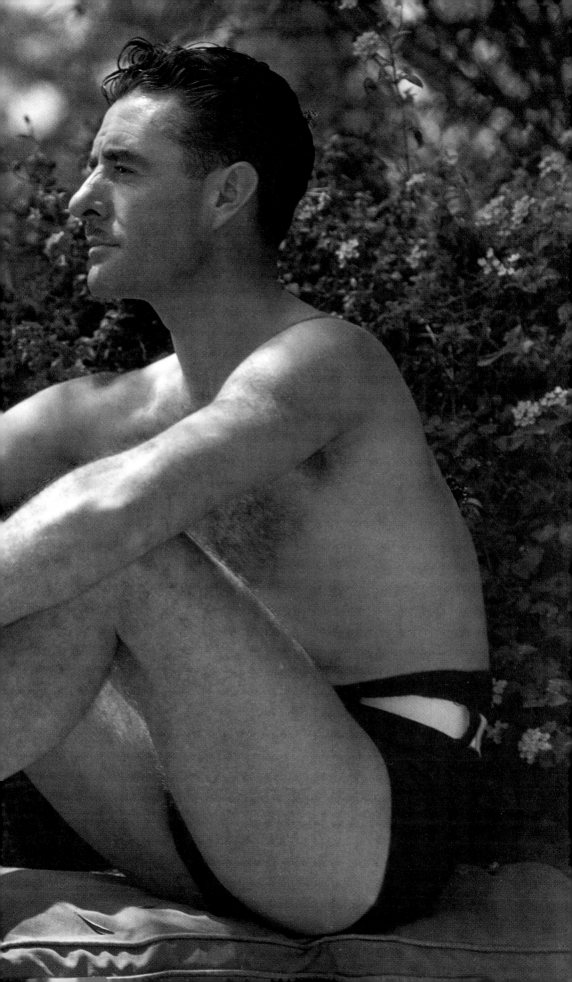

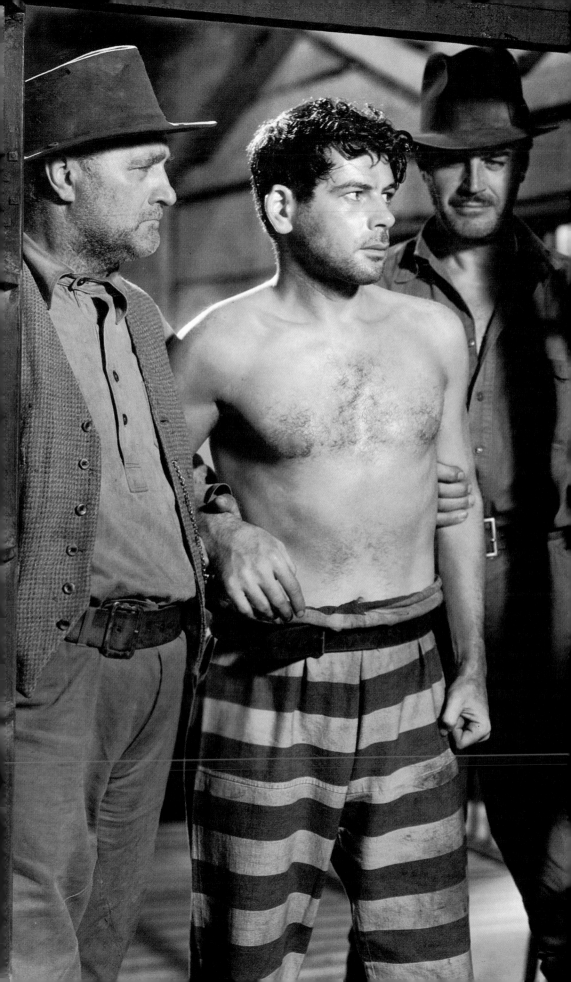

O f course, the exact opposite type of film from the ever-popular rich man fantasies of the thirties were movies that dealt with social issues. Here are screen stills from two notable examples: *I Am a Fugitive from a Chain Gang* (1935) and *Emperor Jones* (1933). Both focused on the trials of the common man. Also notice that in both cases, unshaven faces, body hair, and a great deal of sweat were used to imply lower-class status and the depths of man's degradation. (Rich people—as you know—always had a razor, fancied sleek over shaggy, and never got sweaty.)

this spread: PAUL MUNI (b. Muni Weisenfreund, September 22, 1895, Lemberg, Austria. d. 1967.) A gifted, multi-award-winning actor (an Oscar winner for *The Story of Louis Pasteur*, 1936), Muni excelled in playing roles with social relevance that often called for him to get down and dirty. Though his body is not exemplary by today's standards, his physique did possess a certain healthy fortitude—even when his characters were at their lowest ebb. He spends much of his time barechested onscreen in *I Am a Fugitive from a Chain Gang*. The film is also an early entry into the prison genre, which in the ensuing years would prove an abundant source for glimpses of the male body. (*Kobal*) *below:* PAUL ROBESON (b. April 9, 1908, Princeton, New Jersey. d. 1976.) Though he appeared in few major Hollywood productions, Robeson is considered a key figure among African-American entertainers. A graduate of Rutgers and Columbia Law School, Robeson took a surprise turn by following the bidding of playwright Eugene O'Neill to star in two of his plays. One was the acclaimed theater production of *Emperor Jones,* which was made remarkable by the presence of a shirtless black man who was not a jungle native. Acclaimed for his rendition of "Old Man River" (from *Showboat,* 1937), Robeson had a tumultuous career that hit even more controversy following his association with the communist party, which resulted in the revoking of his U.S. passport in 1950. (*Kobal*)

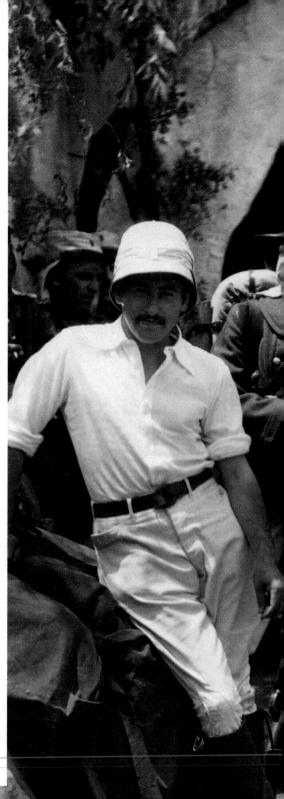

Two movie genres saw increasing popularity in the thirties—the desert epic and the South Seas island adventure. Not too incidentally, they were also surefire guarantees of a peek at a little (or a lot) of manly muscle.

this spread: GARY COOPER (*b.* Frank James Cooper, May 7, 1901, Helena, Montana. *d.* 1961.) Though he was exceptionally tall, "Coop" had an exceptional body, which was put to good use in physically demanding roles as soon as he entered films. His towering muscular presence countered with laconic mannerisms made him unique among top male stars. Truly a man's man. Film still from the 1930 film *Morocco*. (*Kobal*) *below:* JON HALL (*b.* Charles Hall Loeher, February 23, 1913, Fresno, California. *d.* 1979.) After Hall donned a floral-print loincloth to show off his muscular upper *and* lower body in the popular film *Hurricane* (1937), most of his roles to follow were set in warm climes where it was plausible to have him appear tanned and shirtless—as often as possible. He may have been a victim of typecasting, but really, who's complaining? (*Everett*)

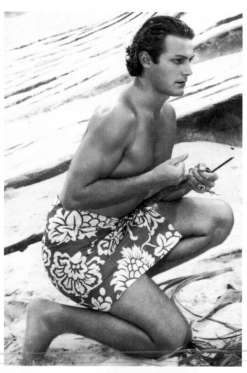

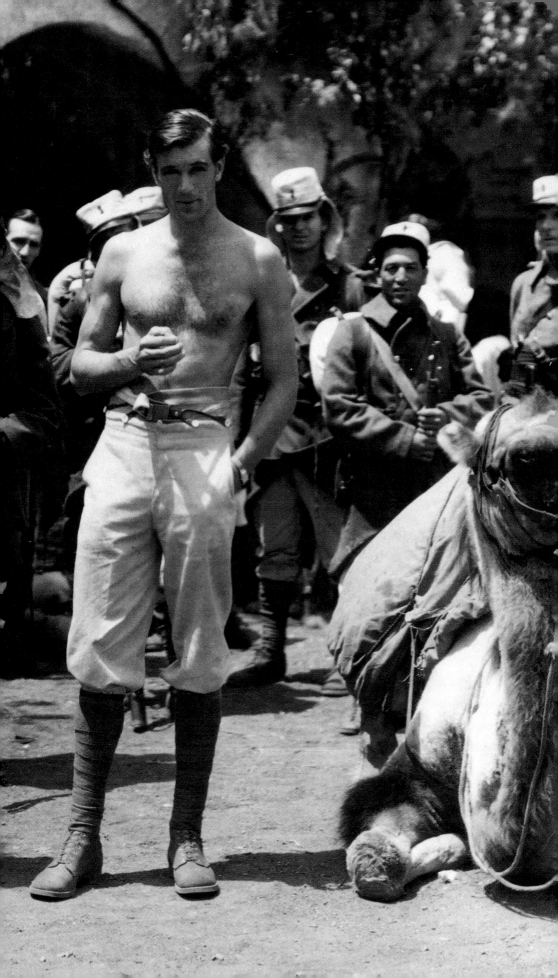

The king, *CLARK GABLE* (*b*. February 1, 1901, Cadiz, Ohio. *d*. 1960), possessed the quintessential male body of the thirties. It was athletic, without being overly muscled, slightly barrel-chested with round, broad shoulders—and with just a hint of chest hair down the middle of the upper torso. Because he excelled in roles that were the fantasies of the American male—never too slick and never too sodden—everything about him was imitated, including the style of his attire. The way Gable looked was the way men (abetted by their women) wanted to look. (*Everett*) *below:* One scene from *It Happened One Night* (1934), when Gable was preparing for bed, opposite female lead Claudette Colbert, he revealed that he wore no undershirt—and the first true shirtless male star was born. Not surprisingly, this movie moment reeked havoc on undershirt manufacturers the world over as millions of men opted for the "naked-under-my-clothes" aesthetic. Never before had the power of a star's image proven so instantly potent. (*Everett*)

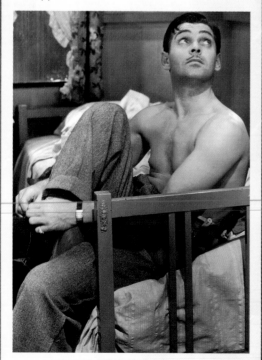

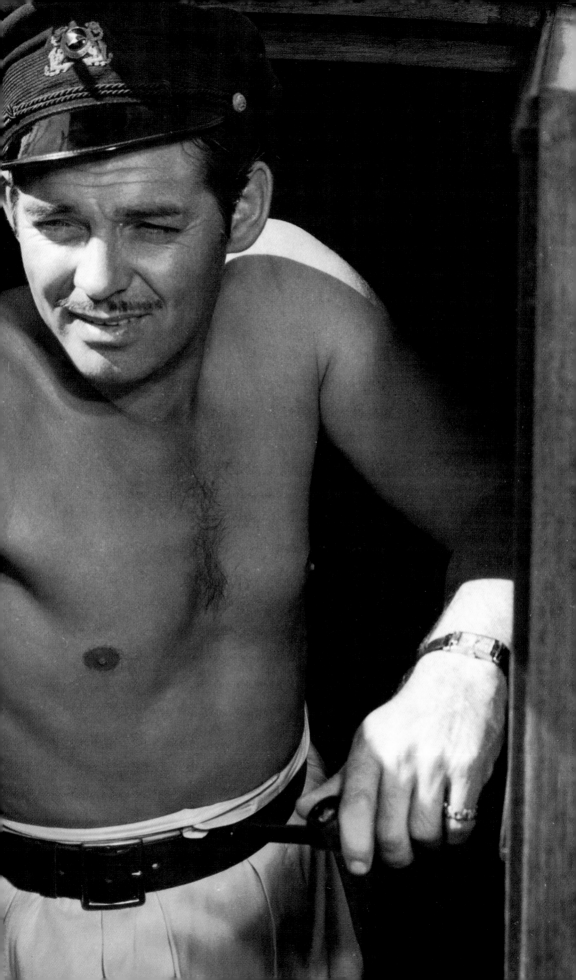

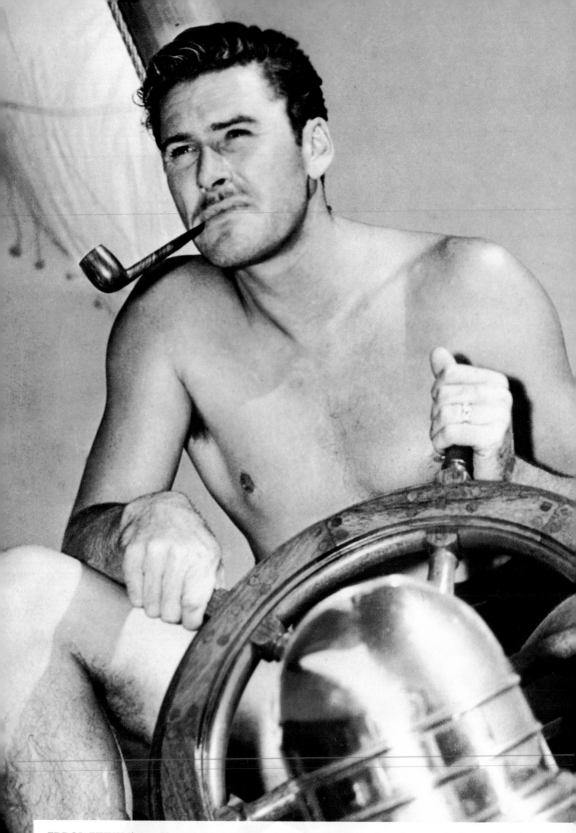

ERROL FLYNN (*b.* June 20, 1909, Hobart, Tasmania. *d.* 1959.) This superbly handsome Tasmanian "devil" was perhaps the only true physical rival to Clark Gable during the thirties and forties (*The Adventures of Robin Hood*, 1938, or *Gentlemen Jim*, 1942). But while Gable was able to serve his country during World War II, Flynn was left out due to a combination of maladies. This is even more surprising given that Flynn was so well known for his onscreen athletic prowess. The next-generation top action hero after Douglas Fairbanks Jr. (see page 20), Errol possessed a set of large, rounded deltoid muscles, which made him appear broad and soft at the same time. (*Everett*)

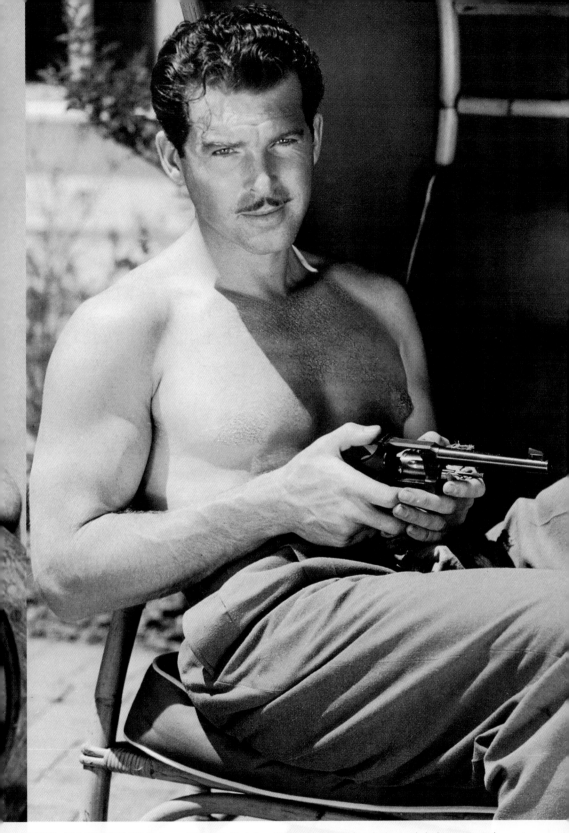

FRED MACMURRAY (*b.* August 30, 1908, Kankakee, Illinois. *d.* 1991.) Often the best male bodies appear in the most unexpected places. Who knew that the man who came to be so popular among sixties television viewers as the ideal father would possess such a well-muscled torso (and dig those biceps!)? This unexpected physicality may have allowed him to play earlier, more diabolic roles (*Double Idemnity*, 1944; *The Apartment*, 1960) than his paternal turns—*My Three Sons*—would lead us to believe. (*Photofest*)

U ntil our official entry (in late 1941) into the Second World War, Americans were happy to remain somewhat isolated from the darkness that was fast encroaching upon the rest of the globe. While we did consider joining in the battle, it was not until the attack on Pearl Harbor that the "Yanks" were forced to enter into the fray. However, from that moment on, if "Hail! the conquering hero" was not the mantra of the American serviceman (and those whom he rescued), it should have been. The mighty All-American savior was born. To back up our efforts, Hollywood led a thinly veiled propaganda push that championed stateside might. While the thirties male movie star was all polish and poise, his forties counterpart was all brawn and bravado—his shoulders nicely broadened to carry the burden of the democratic world's struggle. From Mitchum to Mature—through a revolving door of male stars who enlisted, then returned triumphantly to the screen—the men of the silver screen were bigger and beefier than ever before. A mold was being cast for men's bodies—stars and ordinary males alike—to fill, flow over, or flounder in.

By no small coincidence, the forties also saw the rise of male bodybuilding. While it occupied only a small fraction of the attention of health-minded gents before the war, by the war's close there had been something of a mild revolution. The reason for this increase in popularity was relatively simple: during their enlistment period, servicemen often occupied their training (and free) time with weightlifting. This was, of course, in an effort to make themselves physically more formidable. The rapid gain of musculature (by some, not all) also set the subliminal male mind into motion. What was once largely thought of as a vain undertaking gained respect in the name of the free world. It didn't hurt that men often also felt in competition with each other and that this form of rivalry was a "healthy" way to act out their natural aggression. (In fact, we all benefited. Mmmmm.)

THE FORTIES:
HERE HE COMES TO SAVE THE DAY!

this spread: AUDiE MURPHY (*b.* June 20, 1924, Kingston, Texas. *d.* 1971.) This adorable All-American, freckle-faced boy became *the* most decorated soldier in all of World War II. No wonder that Hollywood came calling when this unassuming lad finished his term of enlistment—even getting him to play himself in the biopic *To Hell and Back* (1955). Too bad that his film career never lived up to the heroic proportions of his battlefield efforts. Here, Audie is extolling the virtues of good exercise to the masses—a byproduct of the armed forces' intense physical training. (*Corbis*) *inset:* GUY MADiSON (*b.* Robert Moseley, January 19, 1922, Bakersfield, California. *d.* 1998.) If there ever was a man who looked the part of Navy poster boy, it would be gorgeous Guy. His body clearly showed the benefits of military training—to great adulation. He was rewarded with a career in films—including *Since You Went Away* (1944) and many Westerns—as he matured into handsome middle age. This photo of our sexy seafarer reminds me of the splendidly exaggerated male body sketches of Touko Laaksonen, otherwise known as Tom of Finland. What do you think? (*Photofest*)

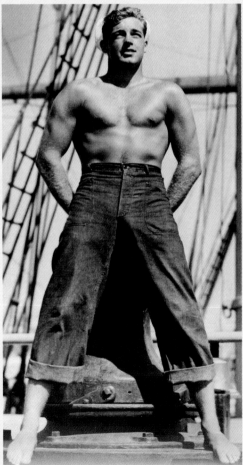

31

above: *VICTOR MATURE* (*b.* January 29, Louisville, Kentucky. *d.* 1999.) During the war years and for a long time after, Mature represented the physical male ideal—watch *Samson and Delilah* (1949) to see him at his peak—even though his coveted barrel chest was offset with a pair of thin-nish legs. However, to his credit this filmdom gladiator did have one helluva great 100-kilowatt smile. (*Photofest*) *this spread:* *ALAN LADD* (*b.* September 3, 1913, Hot Springs, Arkansas. *d.* 1964.) As famous now for being shorter in real life than he ever "appeared" onscreen—at five-foot-six, he stood on a box for many of his shots—Ladd did claim owner-ship to a wonderfully ripped, sun-kissed, and ever-so-slightly-more-hairy body than his peers. He was also one of the few male stars to appear shirtless on a magazine cover. Watch this tiny titan in *The Blue Dahlia* (1946). (*Kobal*)

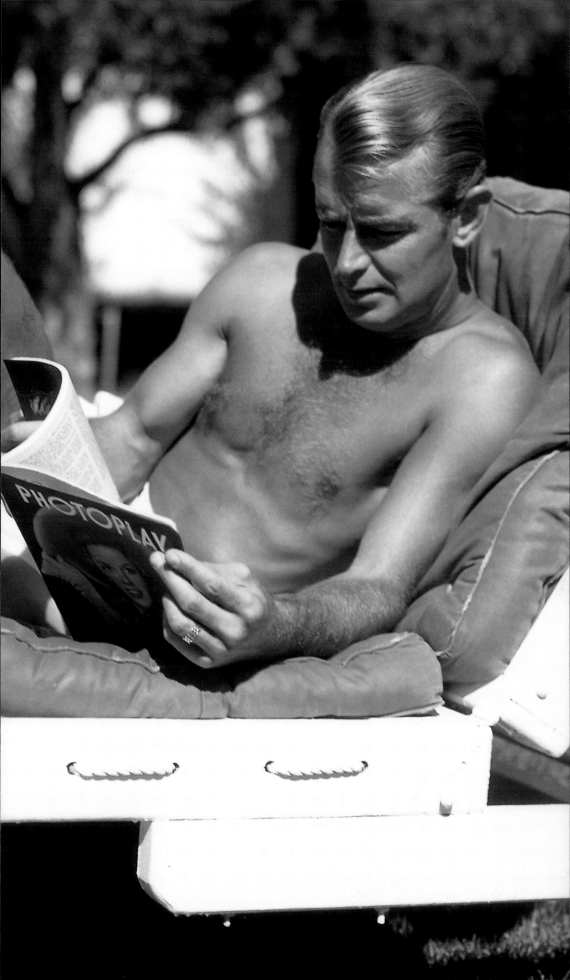

ROBERT MITCHUM (*b.* August 6, 1917, Bridgeport, Connecticut. *d.* 1997.) A brawny, onetime bouncer. For my money, if there were a contest held between the two totems of the forties—Mitchum and Mature—I'd lay my money on Mitchum. He was, after all, a far better actor—an Oscar nomination for *G.I. Joe* (1945)—and there are moments when his body and face were exceptional. However, you'd never want to let this tough guy hear you say that! (*Kobal*)

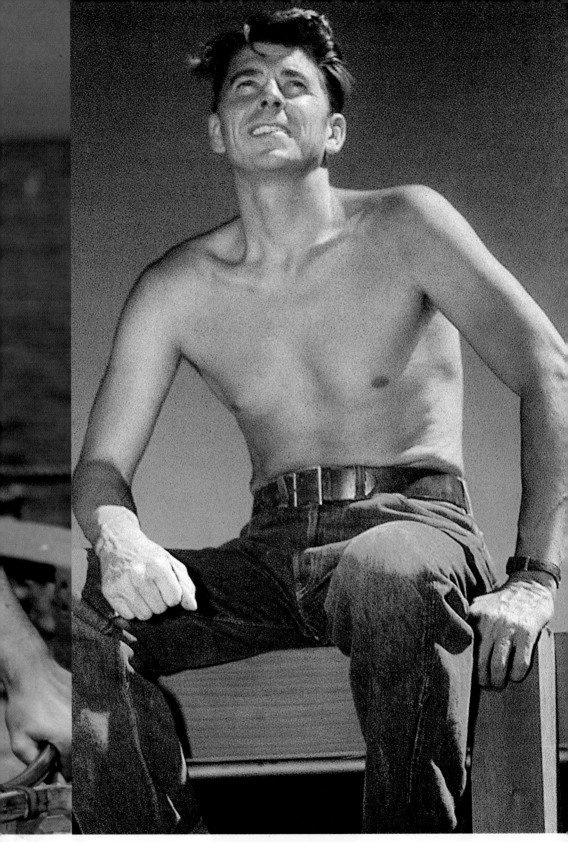

RONALD REAGAN (*b.* February 6, 1911, Tampico, Illinois.) Decades before he was elected president, Reagan had no problem showing off his body. In fact, much of his career involved roles that required of him little more than his physical presence. He also started out politically as a liberal before turning staunchly conservative. (*Kobal*)

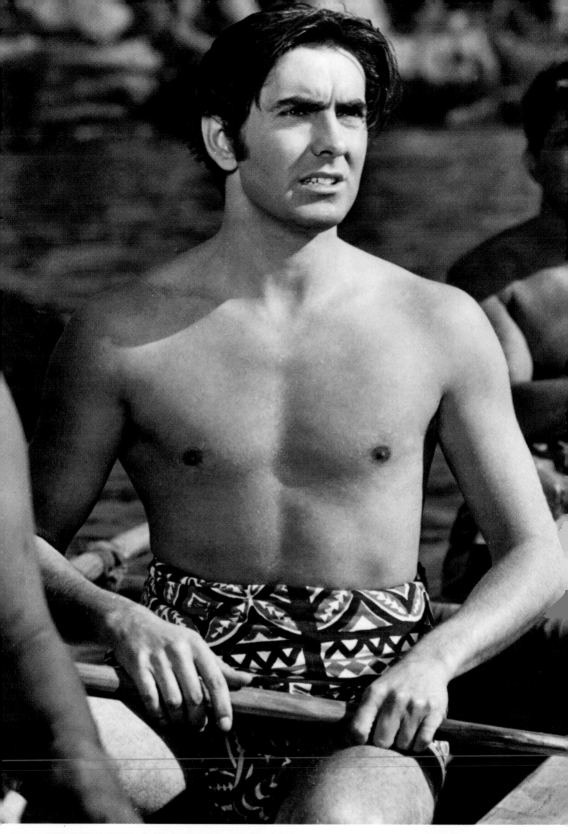

TYRONE POWER (*b.* May 5, 1913, Cincinnati, Ohio. *d.* 1958.) More South Seas adventures with Tyrone Power in a still from *Son of Fury* (1942), where he finds himself a deposed wealthy Englishman in the tropics. Power was another strikingly handsome leading man whose body, though by no means superlative by today's standards, sent moviegoers swooning in the aisles. One could only imagine how remarkable it would have looked with a touch of weight training. (*Kobal*)

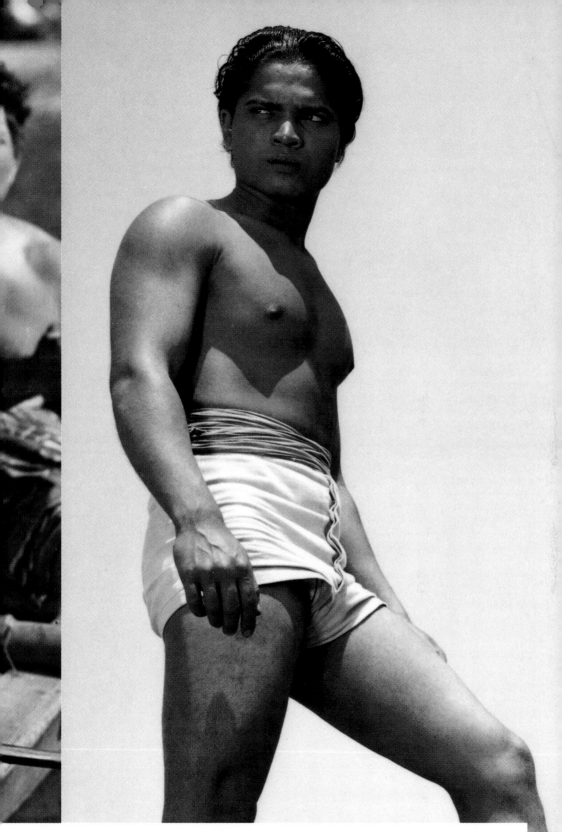

 SABU (*b.* Sabu Dastigir, January 27, 1924, Karapur Mysore, India. *d.* 1963.) Though by and large throughout Hollywood's history any exotic-looking actor (male or female) was used mainly in supportive roles, occasionally one or two would stand out among the throngs of chanting natives. One in particular was Sabu. This swarthy gent came to films purely by accident—at the time of his discovery he was a stable boy to a maharaja. But Sabu's dark good looks would find favor only in forties Arabian-Eastern films, and by the close of the decade his career was largely over. Tragically, he died of a heart attack at age thirty-nine. (*Kobal*)

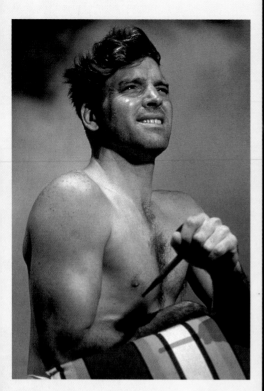

Though their careers would reach a peak during the fifties, both Burt Lancaster and Kirk Douglas began muscling their way to the top of the Hollywood ladder in the forties. *above: BURT LANCASTER* (*b*. November 2, 1913, New York City. *d*. 1994.) Burt was an excellent school athlete (*quelle surprise!*) and began his entertainment career as an acrobat—which would come in handy for many of his screen appearances. His over-the-top acting style also matched his physical derring-do (*Trapeze*, 1956)—the forties and fifties embodiment of the action hero. (*Everett*) *this spread:* However, Lancaster would have to share this unofficial crown for "most physical actor" of the postwar era with *KIRK DOUGLAS* (*b*. Issur Danielovitch, December 9, 1916, Amsterdam, New York.) Douglas, a wrestler who worked his way through dramatic arts school (how's that for an interesting combination of activities?), served in the navy before embarking on his career in films. His first major screen success was in *Champion* (1949), where he played, what else?, a boxer. It was the type of role that would become his signature for years to come—that of a self-centered, tough, and brash antihero. (*Everett*)

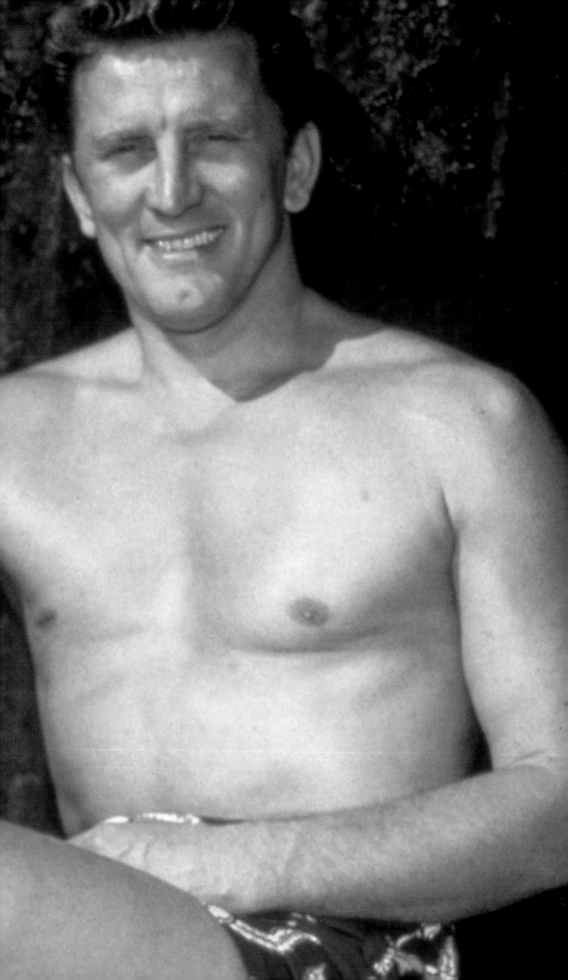

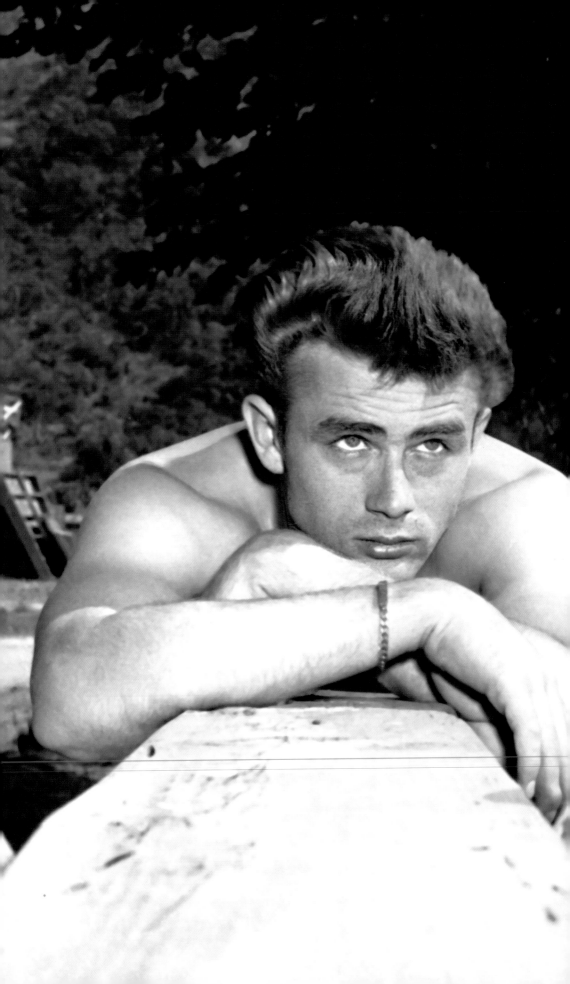

THE FiFTiES:
SEPARATING THE MEN FROM THE BOYS

If the forties saw the birth of the All-American male, the fifties became his home. No decade, before or since, would so universally propagate an individual ideal—both philosophically *and* physically. Years of heroism resulted in the great WASPy, six-foot-plus, grey-flannel-suit-clad patriarch (and, for the most part, he looked as good in his suit as he did out of it). However, as we have become too well aware after time passed, this muscular fellow only spoke to (and for) a limited part of the population. Often, this Eisenhower-era enhanced icon alienated more than he embraced. So a chasm appeared on the cultural landscape and, coincidentally, manifested itself into two opposing physical male ideals. One was beefy and broad (i.e., stalwart, rigid), while his "brother" was lithe and lean (i.e., sensitive, malleable). (However, if comparing either one's overall musculature with *any* top male star counterpart from before the war, there would be no contest. The postwar pretty-boys would always come out on top—so to speak.)

Ironically, the fifties also saw the unofficial end to the enforcement of the censorship Code with the release of the light sex comedy *The Moon Is Blue* (1953). It was released without a seal of approval because producers allowed the word "virgin" to remain in as part of the spoken dialogue. (Heaven, help us!) The film's success brought about a noticeable shift in film content though this did not yet translate into a boon to male body watchers. The Code did not officially come to an end until 1968 when it was replaced by a new ratings system.

this spread: **JAMES DEAN** (b. February 8, 1931, Marion, Indiana. d. 1955.) Nearly fifty years after his death, the Dean legend is still going strong. During his short career, his presence expressed the travails of the fifties troubled teen coming to terms with postwar establishment and prosperity. Thin, but with an obvious developed musculature, his body also represented a new youthful self-awareness and a manner of ambiguous sexuality, both just beginning to make an impact before his untimely demise. (*Everett*) *right:* In direct opposition physically to Dean were body types like that of **JEFF CHANDLER** (b. Ira Groissel, December 15, 1918, Brooklyn, New York. d. 1961), whose barrel-chested stance—seen in *Away All Boats* (1956)—reflected an increasing attention to actual muscular development. Men, young and old, were beginning to realize that just letting a body happen naturally might not be enough to prosper in prosperous times. Chandler's features were also often referred to as "chiseled," a term, likening a man's body to something cut from a rock (i.e., Rock Hudson), that became popular at the time. (*Photofest*)

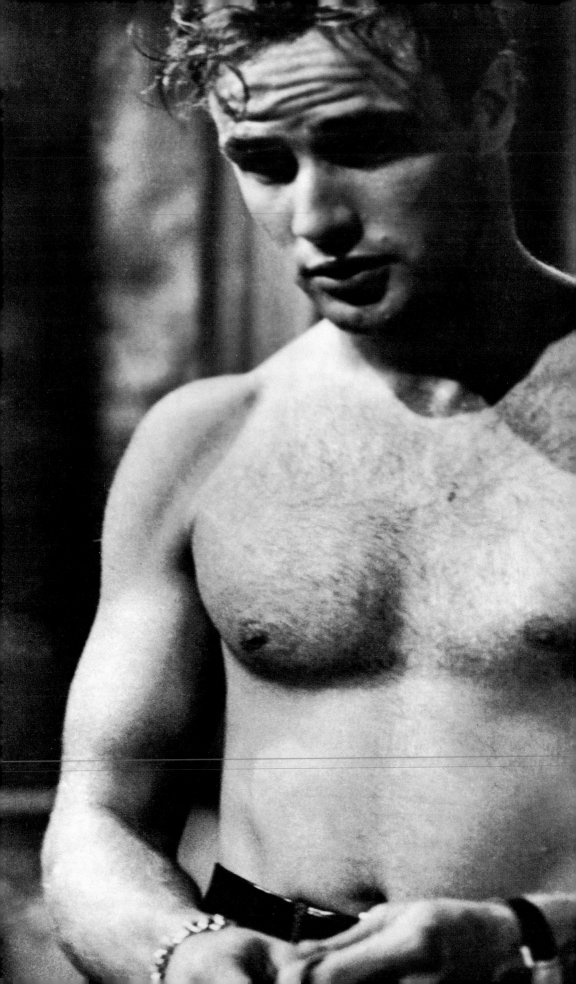

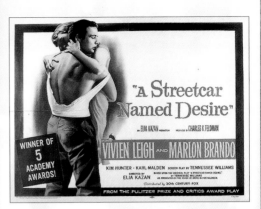

Unquestionably, in terms of how the male body was presented, *A Streetcar Named Desire* (1951) marked an important turning point in cinema. But, not only in regard to how the body was viewed—to a greater degree it advanced the way films to follow would handle sex and sexuality. Never before (or since) has one man's body represented so much raw physical and spiritual power; the all-pervasive temptation of hastening its release (from beneath a wonderfully sweaty tee) served as the underlying motivation of all the characters throughout the picture.

However, were it not for the perfect casting of MARLON BRANDO (b. April 3, 1924, Omaha, Nebraska) in the title role of *Streetcar*—which he repeated from Broadway—the anticipation of uncovering the growling beast from within could have easily amounted to no more than the exposure of a mere meow. Even when he was clothed, Brando's amazingly beautiful body strained like a caged animal. (Today we use stretch fibers to get that look, back then Brando used pure muscle and sex appeal.) Unfortunately, Brando's career never kept up the fireworks set off by this promising start. Every cinematic high was tempered by a film low. And, in the most hard to accept turn of events, today his once-proud physique is buried under layers of time and tissue. (AC/Photofest)

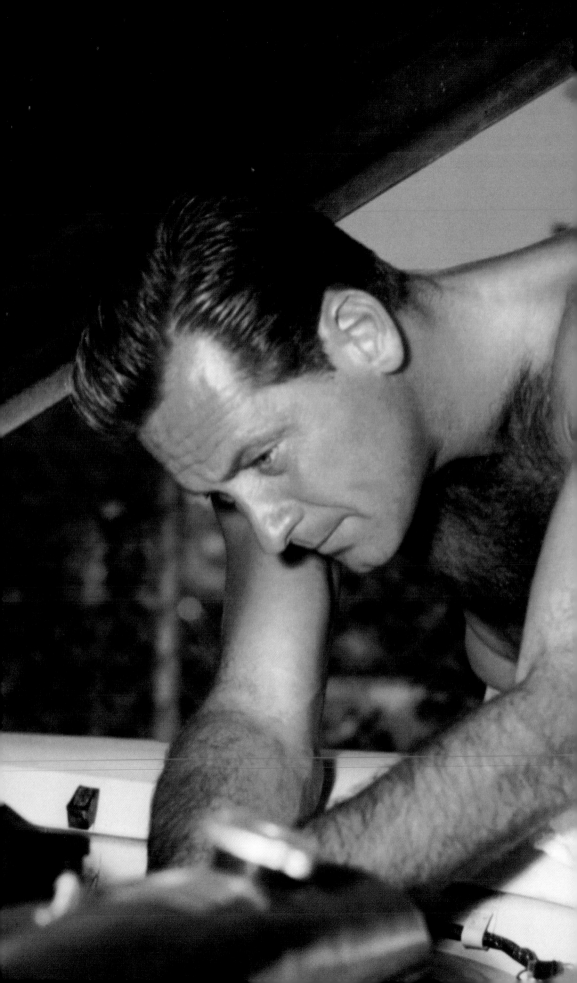

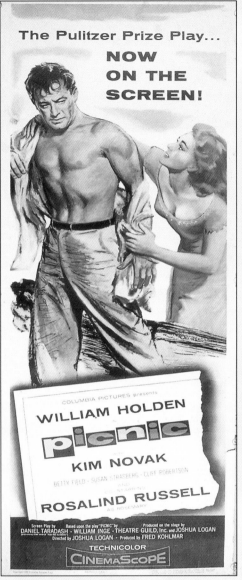

The Pulitzer Prize Play...
NOW ON THE SCREEN!

COLUMBIA PICTURES presents
WILLIAM HOLDEN in

picnic

KIM NOVAK

BETTY FIELD · SUSAN STRASBERG · and CLIFF ROBERTSON

ROSALIND RUSSELL AS ROSEMARY

Screen Play by **DANIEL TARADASH** · Based upon the play "PICNIC" by **WILLIAM INGE** · **THEATRE GUILD**, Inc. and **JOSHUA LOGAN** · Produced on the stage by
Directed by JOSHUA LOGAN · Produced by FRED KOHLMAR

TECHNICOLOR
CINEMASCOPE

WILLIAM HOLDEN (*b.* William Franklin Beedle, April 17, 1918, O'Fallon, Illinois. *d.* 1981.) When Holden starred in *Picnic* (1955), the film version of the Pulitzer Prize—winning play, the sight of his muscular (and shaven) torso sent shock waves throughout the moviegoing public. Holden's body—like Brando's in *Streetcar*—was cause for most of the pivotal moments during the entire film. Beginning with his disrobing to rake a woman's yard through his display of firm and tanned legs stomping around in his father's boots to the climactic moment when a sexually repressed Rosalind Russell rips open his shirt on the dance floor, Holden is pure walking male sex. Of course the real surprise was that Holden, though far from being over the hill, was initially considered too old for the part (at thirty-seven, by about ten years). But more power to him as a "mature" man who could hold his own body against all comers. (*Photofest/Corbis*)

45

For a while during the silent era, the "Latin lover" was an integral part of the upper realms of male superstardom. Valentino and Novarro were highly sought after, and their mannerisms widely imitated. But, with the coming of sound their dashing dark looks fell out of favor. Then, when South America became a popular destination during the Second World War, the love affair was rekindled. Splendid Technicolor was well suited to the tropical locales of this colorful fellow and a popular new film genre was born (coincidentally, with that of the Arabian Night–type picture). Suddenly anything (and anyone) with a south-of-the-border touch was golden again—and stars like Don Ameche, Fernando Lamas, and Ricardo Montalban were queuing adoring fans across the country.

this spread: RiCARDO MONTALBAN (*b.* November 25, 1920, Mexico City.) One of the screen's most memorable "Latin lovers," Montalban also possessed one of its best bodies, ever. From early swimathons such as *Neptune's Daughter* (1949) through *Sayonara* (1957) to *Star Trek: The Wrath of Khan* (1982) his body was splendid to behold. He also fought long and hard to overcome ethnic typecasting—the diversity of his roles shows a great measure of success. (*Corbis*)

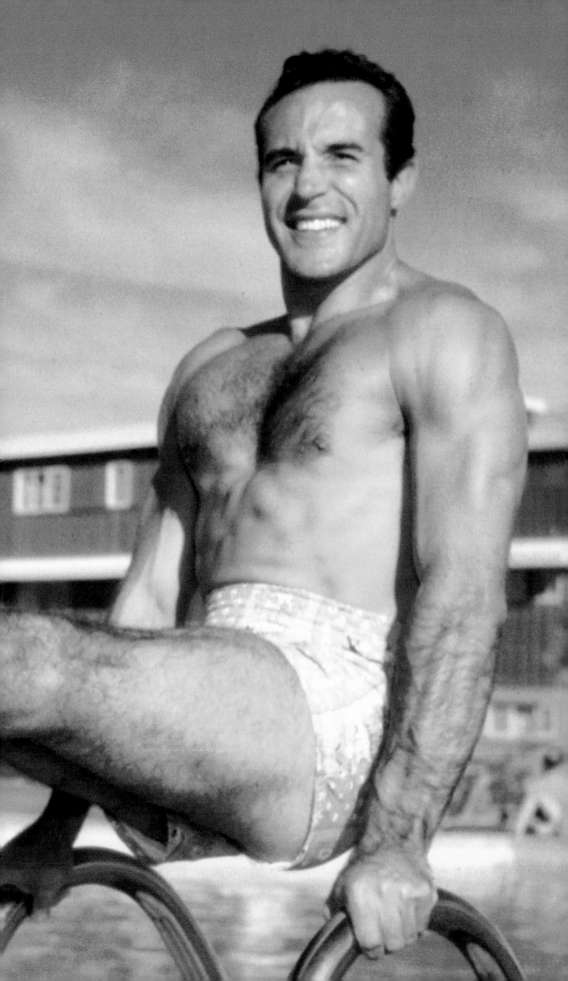

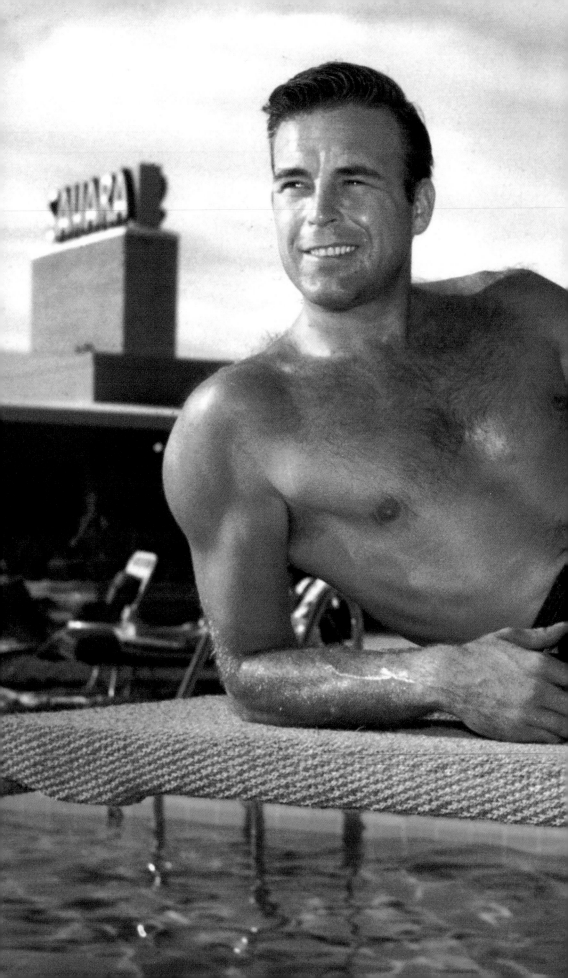

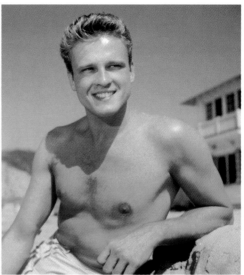

All on board! These two hunks are fast at work on their movie star tans. I thought it especially interesting to note that with only two years separating them in age, blondie (Ericson) was often cast in the boyish, good-guy role, while tall-dark-and-handsome (Brady) was more likely to portray the older gun-wielding toughie. Is it a surprise that hair color and a hairy chest play such an important role in the path of an actor's career? No. So it's a good idea to know the name of a great hairdresser, boys.

inset: JOHN ERICSON (*b.* Joseph Meibes, September 25, 1926, Dusseldorf, Germany.) The screen's *Pretty Boy Floyd* (1960) did not make it to the absolute top ranks of stardom—which is a puzzle given such a great bod, handsome face, and fine acting skills (he trained at the American Academy of Dramatic Arts). (*Corbis*) *this spread:* SCOTT BRADY (*b.* Gerald Tierney, September 13, 1924, Brooklyn, New York. *d.* 1985.) This handsome former lumberjack and boxing champion excelled at playing in Westerns—including *Johnny Guitar* (1953)—early in his career. His brawny presence was also seen a great deal on television through the seventies. (*Corbis*)

TAB HUNTER (*b*. Arthur Gelien, July 1, 1931, New York City.) When the first teen wave hit stateside (and around the globe) Tab was there to meet it on the frontlines. His All-American good looks—face and body—were the perfect match for a country hungry for new male idols. Our coverman is also an accomplished ice skater and horse rider. Look for him in *Battle Cry* (1955). (*Kobal*)

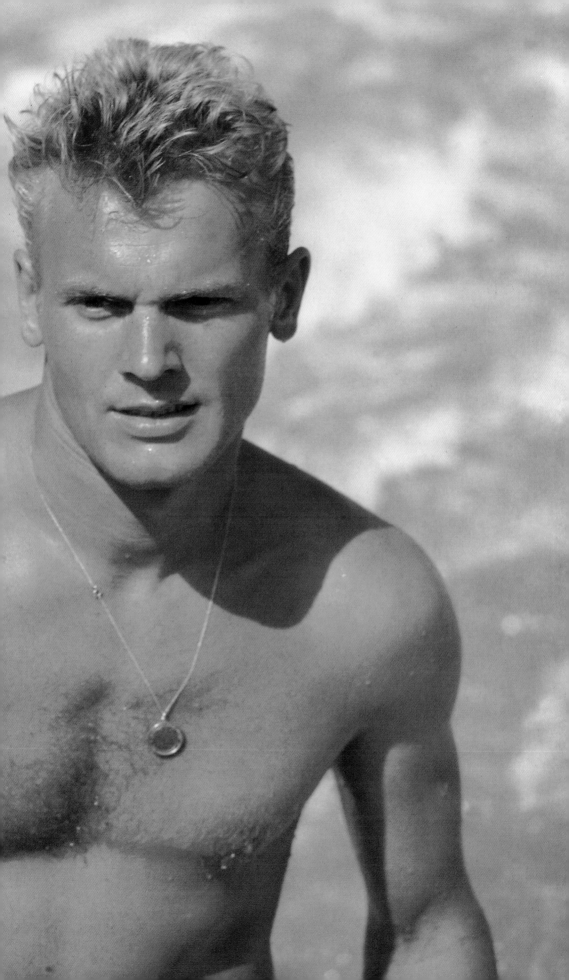

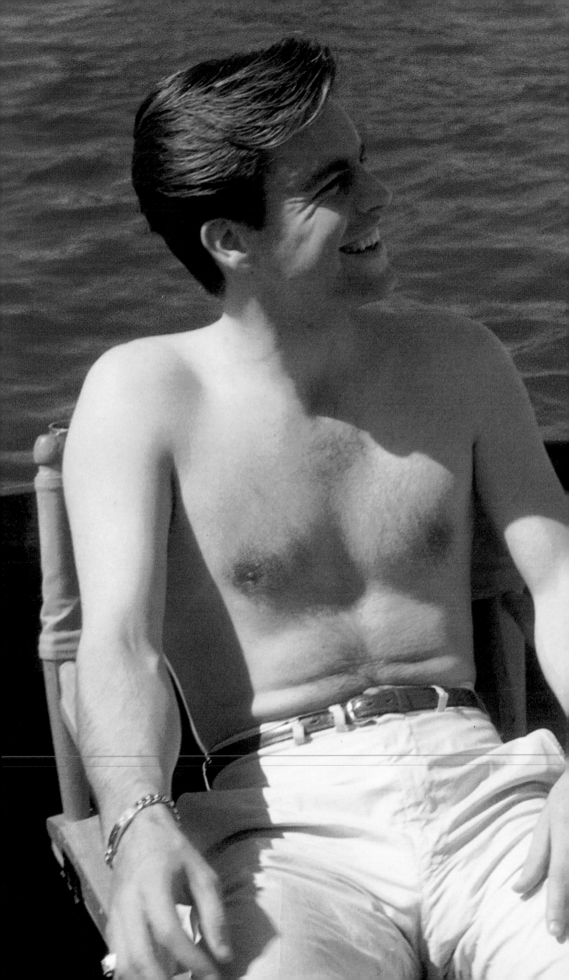

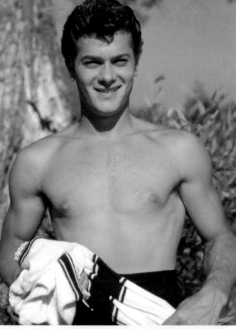

Two of filmdom's "princes" who won the hearts of millions of subjects with their youthful matinee-idol looks.

this spread: ROBERT WAGNER (*b.* February 10, 1930, Detroit.) Though a tad bit long in tooth to actually be considered a "teen" idol, Wagner did what so many men often do as they grow from youth into maturity—they get even more handsome. Wagner was cute as a twenty-something male starlet (*Prince Valiant*, 1954), but ever more the devastating dude once he added just a few pounds of real muscle to his frame (*All the Fine Young Cannibals*, 1960). By the time he reached his thirties he was in clover. (*Corbis*)

inset: TONY CURTIS (*b.* Bernard Schwartz, June 3, 1925, Brooklyn, New York.) Curtis was already something of an established star when the first onslaught of baby boomer fandom swept the nation, but his pretty-boy looks and finely muscled body—see *The Prince Who Was a Thief* (1951) and *Houdini* (1953)—helped him to stay at the top of the beefcake heap. (*Corbis*)

A fifties fashion moment. Though men were quickly losing their shirts, the pants *always* stayed on. (Oh, well.) But, not only did they stay on, they were too often cut unflatteringly high *and* loose. As it was for women, a show of the navel was still considered *verboten*—the sight of a belly button did, after all, lead your eye down the torso to you-know-where: the groin! Therefore, it was infrequently, if ever, seen (even in swim apparel—see pages 46–53). However, not to despair. Full exposure of the lower torso was just around the bend.

Regardless of the anticlimax of seeing them with their shirts off *and* their lower torsos covered, here are two highrise waist-wearing hunks from both ends of the beef spectrum. In this corner, we have a babe for the younger set, *jEFFREY HUNTER* (*b.* Henry Herman McKinnies Jr., November 25, 1925, New Orleans. *d.* 1969), who made a splendid Christ in *King of Kings* (1961). (*Corbis*) For the slightly more mature-leaning crowd, we have on this spread *RiCHARD EGAN* (*b.* July 29, 1921, San Francisco. *d.* 1977) in a pretty pair of dressy white slacks. Though the ages between these two men was inconsequential (little more than four years), Jeffrey's slim build and boyish good looks predestined that he would become an idol for the teen crowd, while Egan's robust physique had him play father, or, if you prefer, "daddy" types (*A Summer Place*, 1959) while he was still in his thirties. (*Corbis*)

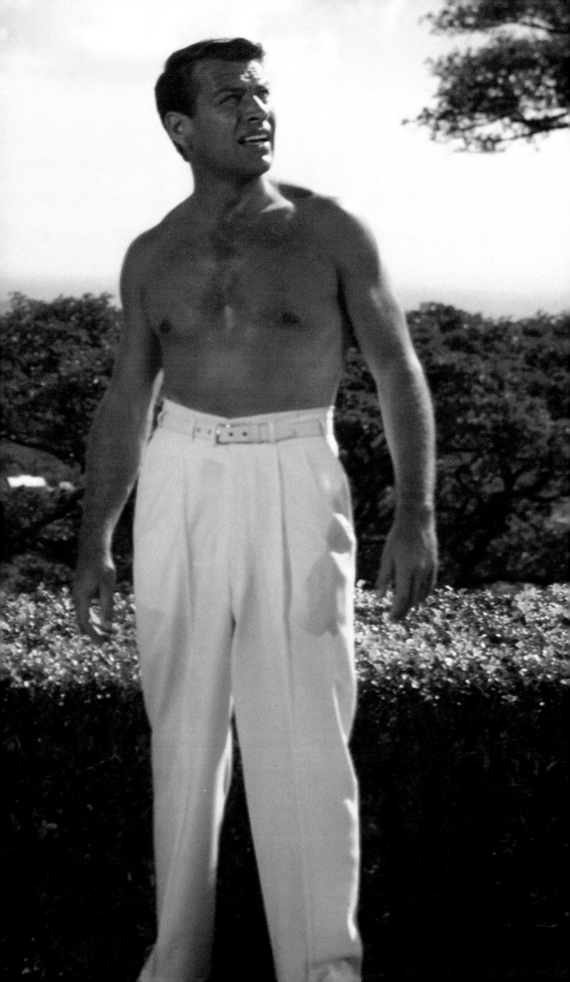

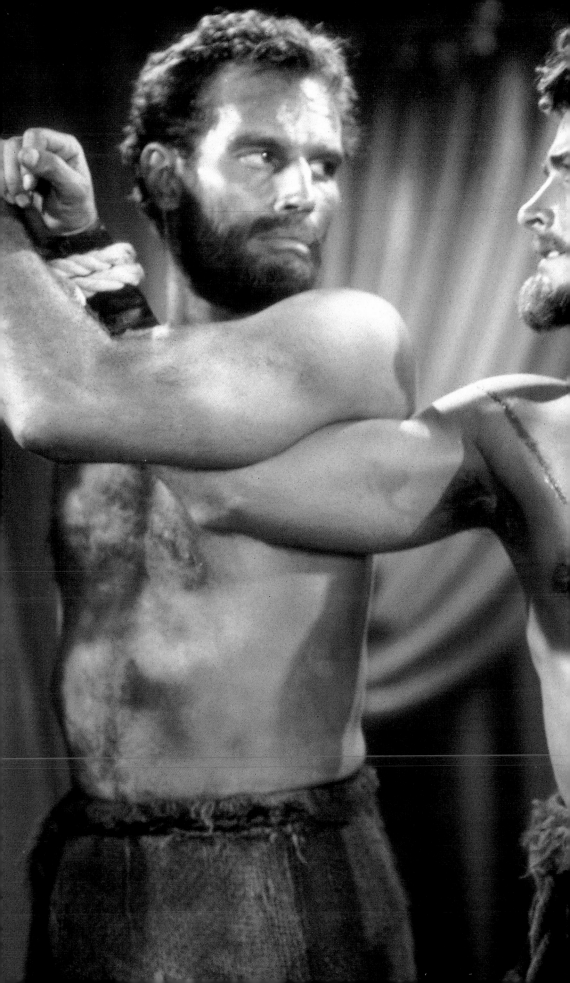

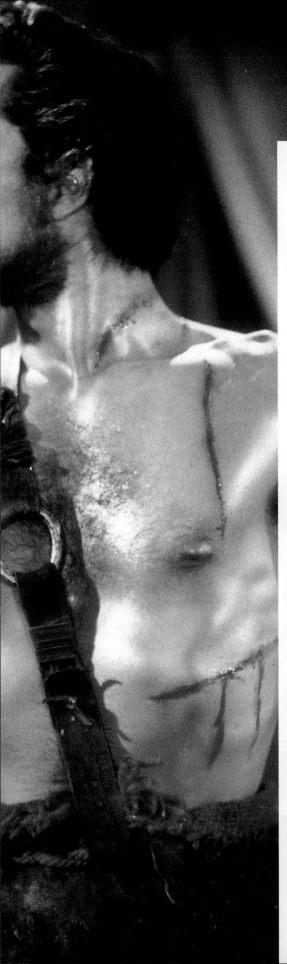

For better or worse, no one did a more memorable job of bringing religion to the masses than Hollywood. Though at times wholly inaccurate in its accounting of ancient times, the famed Tinseltown "biblical" was a fifties entertainment of choice—if you could stand all the Technicolor, Cinemascope, and melodramatics—and full of beefy boys waiting to be saved.

One superlative example of this ecclesiastic excess, which also offers abundant glimpses of male flesh, was the stupendous, over-the-top remake of *The Ten Commandments* (1956) (MPTV). The film featured the delectable male duo of CHARLTON HESTON (*b.* Charles Carter, October 4, 1923, Evanston, Illinois) and JOHN DEREK (*b.* August 12, 1926, Hollywood, California. *d.* 1998), shown here in a moment of impassioned rescue. The film also starred YUL BRYNNER (*b.* July 12, 1915, Sakhalin. *d.* 1985) as the tempestuous Ramses II (*below*). (*Everett*) Full of pagans and prophets, key scenes were this side of orgiastic (the Bible is always good for a tawdry tale or two). Other opportunities to worship at the altar of male muscularity include *The Robe* (1953) and one of the best of them all, *Ben-Hur* (1959). If you're a fan of Brynner's, his signature role in *The King and I* (1956) offers plenty of opportunity to relish his regal splendor.

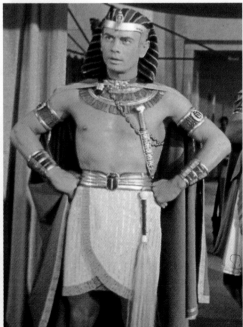

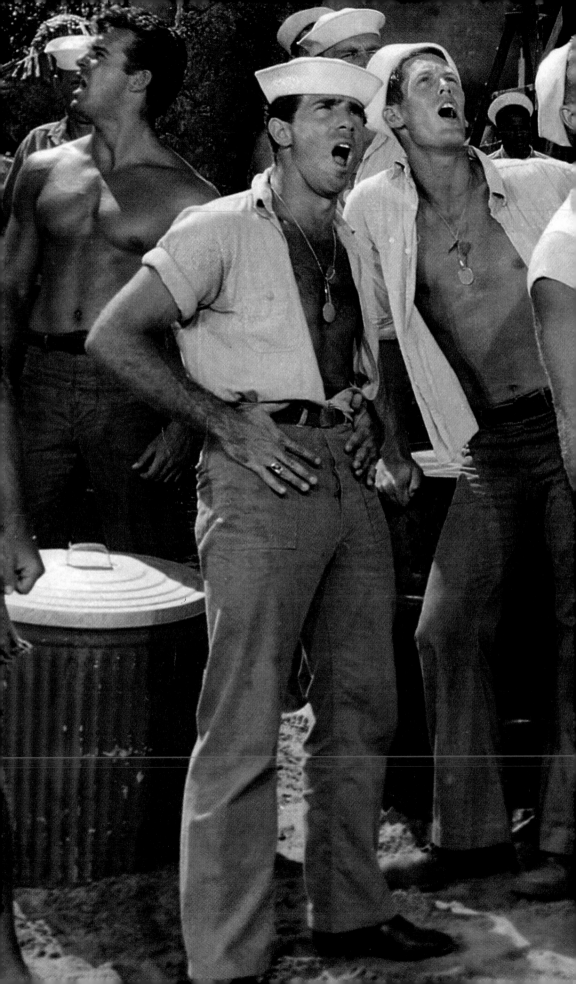

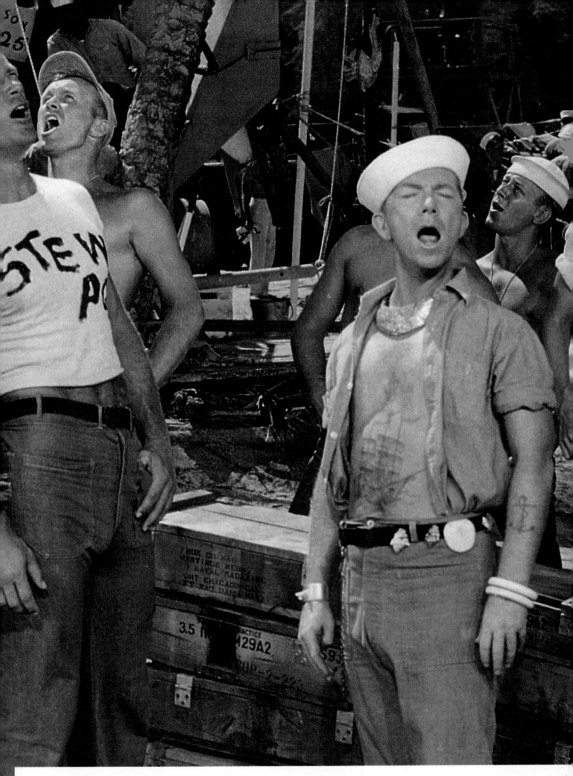

nother perfect opportunity to boy-watch could be found in any film with a South Pacific locale. As visual proof, this film still is from—what else?—*South Pacific* (1958). Any time you have sailors at sea (or on land) the situation is ripe for sweaty and sinewy splendor. Gracious! there doesn't seem to be an ounce of anything other than muscle on any of these fine examples of military might. Notice too, as you get farther south of the equator, the waistline begins to drop. No doubt the "hot" temperature allowed for a more permissive (or would that be promiscuous?) living environment. By the way, the gentleman in the tight white T-shirt in the middle of this photo was nicknamed "Stewpot." At one point, late in the film, he dances in a hula skirt—and, thankfully, nothing else. If blond beefcake floats your boat this muscle-bound moment is well worth the risk of climbing on board ship. (*Everett*)

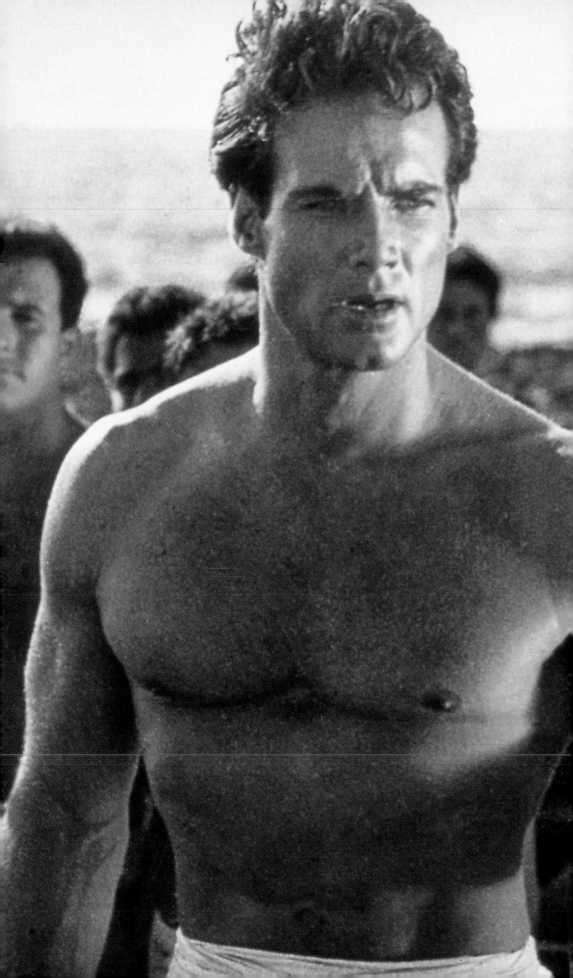

The popularity of (natural) bodybuilding reached its zenith in the fifties. But what began as a seemingly homogeneous endeavor for anxious young heterosexual men took on an inescapably homoerotic edge during the decade of archconservatism. Since no side, straight or (invisibly) gay, would surrender its barbell to the other, a kind of truce was implemented. While on the surface the finest male bodybuilders were lauded and revered by one and all, underneath a great amount of the sport's prettiest proponents enjoyed silent popularity—first in the form of magazines (often miniaturized versions), then on crude film—among the "gay" community. Not too surprisingly, this underground idolatry formed the origins of today's gay male pornography. Thank you, gentlemen.

this spread, left: STEVE REEVES (*b.* January 21, 1926, Glasgow, Montana. *d.* 2000.) Championship bodybuilder (Mr. America, Mr. World, and Mr. Universe) turned international cinema star. Possibly at no time, before or since—including a deference to the indomitable Arnold Schwarzenegger—has so much muscle and beauty been brought together in one glorious package. Though he was by no means a great actor, Reeves parlayed his impressive physical stature into cinematic gold with a series of cult-classic mythological hero roles filmed in Italy. Knowing that Reeves developed his splendid physique naturally—look for it in *Athena* (1954) or *Hercules* (1957)—makes his body all the more satisfying in these post-steroidal times. (Like the slightly built costar to his left— I'd be enrapt of this blue-eyed hunk, too.) Film still from *The Giant of Marathon* (1959). (*Everett*)

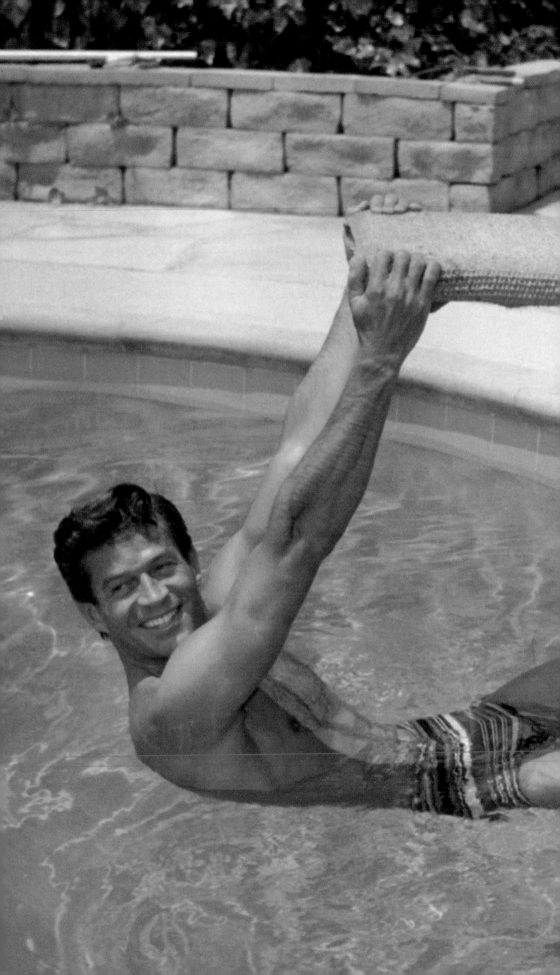

GEORGE NADER (*b.* October 9, 1921, Pasadena, California.) Almost too handsome and well built for his time—see *Away All Boats* (1956)—Nader had a career that never reached the heights his tanned and muscled legs could have easily climbed. Notice that he also had a more plentiful amount of body hair than most of his predecessors. Nader knew he had a beautiful body and was not ashamed to show it at every opportunity (unfortunately, little of his work lives up to his towering presence). Fortunately, his body consciousness made him a forerunner of male leads for years to come. (*Corbis*)

HUGH O'BRiAN (b. Hugh J. Krampe, April 19, 1925, Rochester, New York.) At one time one of the military's youngest drill instructors (boot camp heaven!), O'Brian had a physical quality about him that lended itself quite well to the laid-back lifestyle of the California sun—a late example, *Love Has Many Faces*, 1965—though he was most popular as a Western star on television. Given the chance (and photo opportunity) he, like George Nader, seemed never to let a moment pass by when his shirt would go missing and his tanned, hairy chest was thrust into prime display. Like two very macho beach boys, their appeal was marketed to a more seasoned audience. Nevertheless, they were a more sexual and slimmer version of the hulking he-men that dominated film coming into the fifties. (*David Sutton/MPTV*)

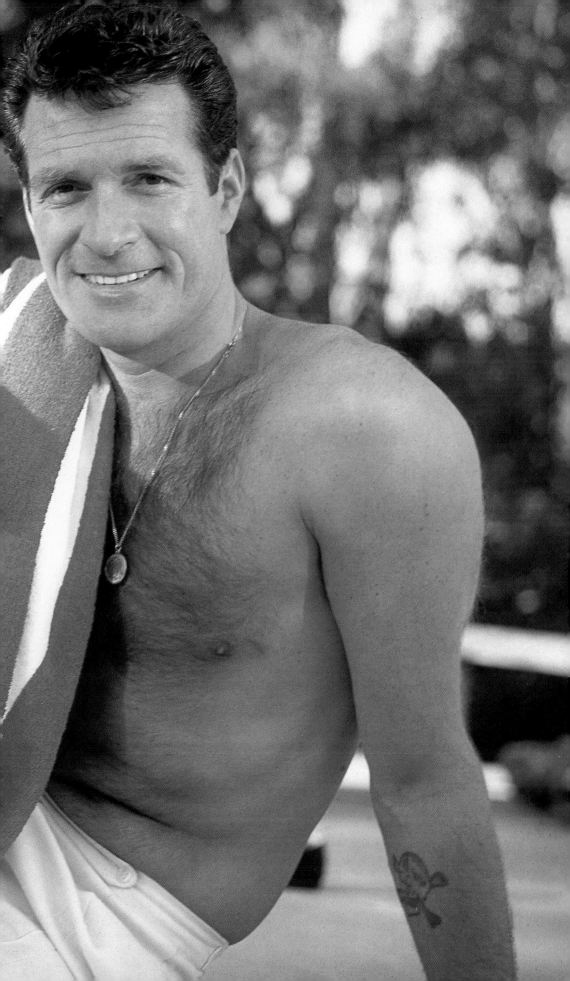

ast on the other side of the coin forged for "men" like Nader and O'Brian were the "boys" who brought gold into Hollywood's coffers. An onslaught of male teen idols hit around the middle of the decade, to the delight and satisfaction of the first group of baby boomers. Along with this initial payload, consisting of Tab Hunter, Jeffrey Hunter, Tony Curtis, et al., each subsequent year brought with it an even younger minting of muscular males. By decade's end, they were little more than post-pubescent playthings barely of high school age. Consideration of this male jailbait was an altogether new thing for Hollywood and its denizens. For the established (i.e., older) male star, it sparked a frantic effort to hold back father time. This rewarded moviegoers because the slack body became a thing of the past, replaced by the firm figures of youth. But we may have lost more in the bargain. From that moment on, the relative lack of age was perceived as a positive, while seemingly negating the benefit of years of experience.

I deliberately decided upon this one example of beauteous youth because he became well known to myself (and millions of others) not as a teen idol but as "Dano," the cohort of Jack Lord in the long-running television series *Hawaii Five-O*. But *JAMES MACARTHUR* (*b*. December 8, 1937, Los Angeles), early in his career, was an angelic-looking babe (similar, aesthetically, to Leonardo DiCaprio), who first came to our attention in the late fifties and early sixties, most notably, in Disney's *The Swiss Family Robinson* (1960). The adopted son of Helen Hayes and Charles MacArthur was, in a word, adorable. Still, MacArthur became neither a great star nor a statistic of too-early fame. He merely lived and worked as an actor—treating it like any job. Success in Hollywood does not always have to exist in the realm of the superlative. (*Corbis*)

67

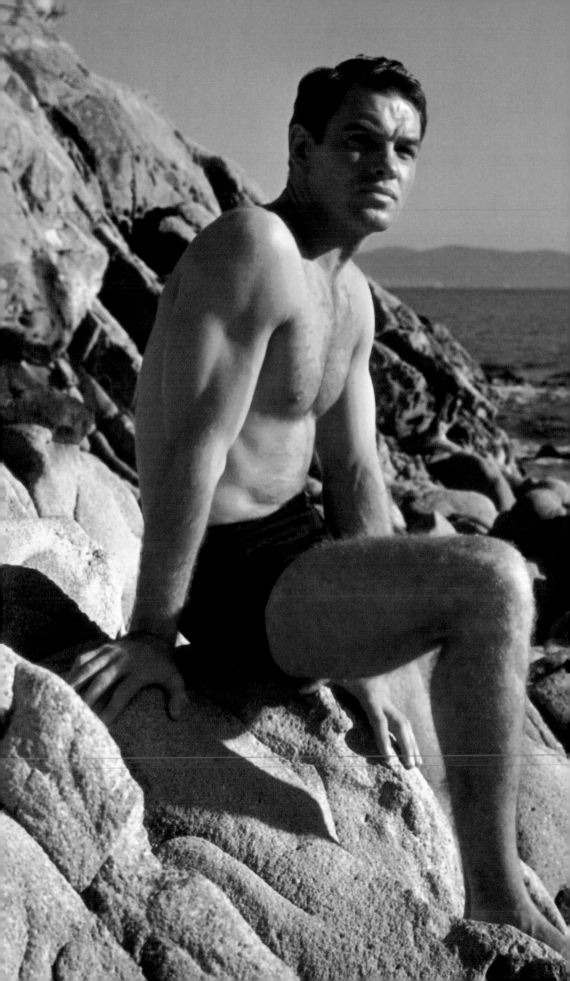

ometimes, all it comes down to in life is finding a gorgeous hunk o' man sitting alone in a swimsuit by the sea. Right? Unencumbered, unadulterated, and unassailed (but possibly not for long!).

MARK DAMON (*b.* Alan Harris, April 22, 1933, Chicago) This handsome slab of beefcake may have never made it to the highest heights of domestic stardom but, in the early sixties, ventured overseas to play the lead in many an Italian film. He returned stateside to become a quite successful producer of an eclectic assortment of films that includes 1987's *The Lost Boys* (see also pages 132–33). Since the majority of his films are European, they are likely unavailable for viewing. I suggest trying to catch him in Roger Corman's film *House of Usher* (1960) if you want to see him in his prime. And who wouldn't? (*Corbis*)

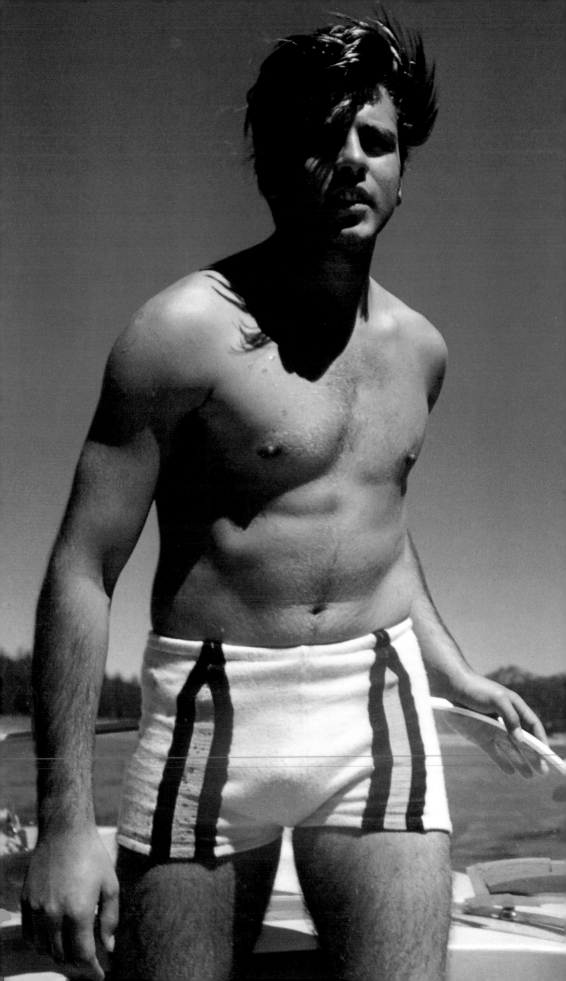

CONNIE STEVENS: World's Largest COLOR Pinup!

Teen Screen
SWINGIN' SURFIN' ISSUE!
WIN PAINTINGS BY ANNETTE!
Everybody Wins Annette's Pics!
Win Dick Dale's Hand Painted Shirts!

PAUL PETERSEN and LYNN LORING
MAKE THE MUSEUM SCENE!

COLOR PICS OF:
Annette, Troy, Debbie Walley,
Fabian, Cindy Carol
AND MANY MORE!

ROD LAUREN SHOT!

IS FRANKIE AVALON
TOO JEALOUS?

CLARA RAY TELLS ALL ABOUT DICK CHAMBERLAIN!

WIN! WIN! WIN! 100 Fabulous Surfing Albums!

he cultural separation that began in the fifties split even further in the sixties. Fortunately, while the young of America held onto their half and the establishment theirs, this impasse did not impede the flow of fabulous male physiques. However, the omnipresence of the cold war saw a sixties warming trend with the introduction of the hirsute he-man—albeit in sleeker form. But, he was perfectly balanced with the smooth, golden-tanned beach boy. The rapid rise of pop(ular) music—a new venue for near-juvenile males—made certain that youth (or the young at heart) would still ultimately rule the day.

this spread: FABIAN (*b.* February 6, 1940, Philadelphia.) A favorite of the ever-burgeoning teen market, first through his bubblegum pop music then through his light film career (*North to Alaska*, 1960). Though a bit on the stocky side, he perfectly reflected the surfer-dude ideal that dominated teen tastes during the first half of the sixties. Later, in his thirties, with an even more impressive physique, he shucked all to appear nude in *Playgirl* magazine in the seventies. (*Corbis*) *above:* RICHARD CHAMBERLAIN (*b.* March 31, 1935, Beverly Hills, California.) Unarguably, a near-perfect example of wholesome California masculinity, Chamberlain played *Dr. Kildare* for six years on television, then graduated to the miniseries *Shogun* by the eighties. A film of note: *Twilight of Honor* (1963). Did you notice the upended surfboard? It was a popular prop in many photo shoots during the halcyon beach days of the sixties. It's hard to ignore the subliminal phallic symbolism. (*Author's collection*)

The youth movement that began in the mid-to-late fifties—and was barely containable under the restraints of fifties conservatism—broke through in the early sixties. One very important reason for this tumbling of the walls of Geritol came with the 1960 election of John F. Kennedy. Not unlike a similar shift in cultural attitudes that would occur with the election of William Jefferson Clinton in the nineties, the ascension of Kennedy to the most powerful job in the world undermined the security of the old establishment. Simply speaking, because the president was young (forty-two), the entire nation and the world embraced a more youthful outlook. So everywhere, from the hinterlands to Hollywood, men (and women) of *all* ages began to assimilate younger attitudes toward life (and looks). It was a welcome clearing of the air, gone musty with age. The new ideas brought in with this new administration helped to pave the way for more significant cultural changes to come.

Chosen by President Kennedy to portray himself as a young naval officer in *PT109* (1963), CLiFF ROBERTSON (*b.* September 9, 1925, La Jolla, California) was already a seasoned actor when this windfall role came his way. Though an Oscar winner for *Charly* (1968), Cliff never looked handsomer (or more presidential) than in this cinematic tribute to an equally comely commander-in-chief. (*Corbis*)

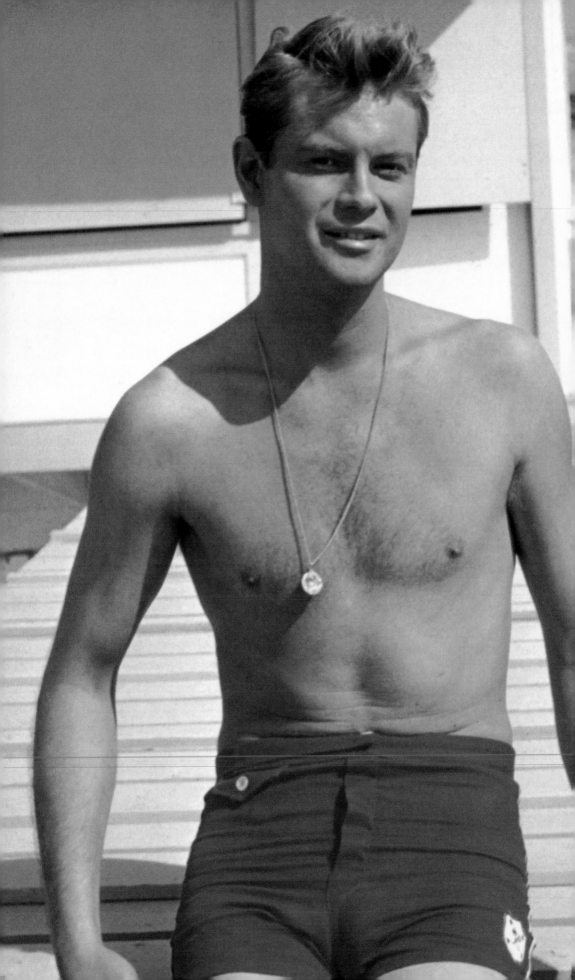

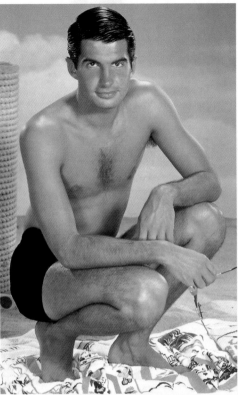

While the California beach was a dominant locale for films during the early sixties, the "craze" actually began with a picture set in Ft. Lauderdale, Florida. Though lacking real heat in terms of body temperature, *Where the Boys Are* (1959) proved such a hit among the youth crowd that it set into motion this waterlogged spate of films.

inset: GEORGE HAMiLTON (*b.* August 12, 1939, Memphis, Tennessee), from the cast of *Boys*, a man whose mere presence is now synonymous with suntan. At the time, a tan usually meant three things for a man: one, he was part of the working class or outdoorsy (often resulting in an undesirable "farmer's tan"); two, he was part of the monied elite (including movie stars) who could afford a swimming pool or vacation in some sunny clime; or three, he was separated from the fairer sex—men were always shown with a slightly darker skin tone. However, by the time of *Boys*, a suntan marked something of a right-of-passage for the male youth of America. No longer a definer of class status, it signified an introduction into the adult world, where the sexes intermingled and sexuality was handled with a certain amount of abandon. (*Kobal*) *this spread: TROY DONAHUE* (*b.* Merel Johnson, January 26, 1936, New York City.) Supplanting the more svelte Tab Hunter as the blond poster boy for squealing teens from coast to coast in the early sixties, the more rounded Donahue was a top star for only a short while before fading from the sunshine. (*Corbis*)

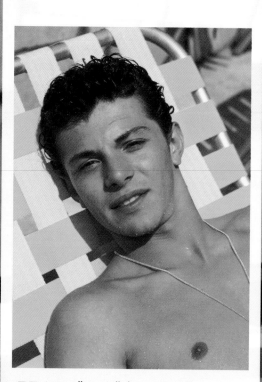

Knowing all too well that we were plunging into a culture that judged a man by how well he looked in a swimsuit, many of the day's popular singers quickly got into the swim of things.

this spread: PAT BOONE (*b.* Charles Eugene Boone, June 1, 1934, Jacksonville, Florida.) Boone's popularity neatly straddled the late fifties and early sixties (how's that for a tempting visual?). His squeaky-clean personage and mellifluous voice wooed many a teenybopper and he was not too bad an actor onscreen (*All Hands on Deck*, 1961). Shown here, he had the ultimate male body of a twenty-something man: toned without looking like he paid it too much attention, lightly tanned, and still to the hairless side of hairy. (*Corbis*) *inset:* FRANKiE AVALON (*b.* Francis Thomas Avallone, September 18, 1939, Philadelphia.) The uncrowned prince of the beach movie was undoubtedly Avalon. Hand in hand with Annette Funicello, he helmed at least a half dozen sandy romps—including *Muscle Beach Party* (1964)—in his ubiquitous square-cut shorts. (Didn't anyone tell him that they give you an awkward tanline?) (*Corbis*)

For all its candy-coated sweetness, early sixties culture also had a palpable dark side that quickly began showing up on film—typically in the guise of a dark-haired male antagonist. The Hitchcock classic *Pyscho* (1960), considered the first "slasher" movie, introduced audiences to a new level of screen violence. While the film itself offered no glimpses of the unclothed male form, it launched a genre that today is rampant with exposed skin (both female and male).

this spread: Psycho also catapulted its star, ANTHONY PERKINS (*b.* April 4, 1932, New York City. *d.* 1992) into international stardom. Specializing in slightly awkward (to say the least) young male characters, Perkins played roles that reflected the dismay felt by many a young man—a continuation of disenchanted delinquents played by James Dean, just a few years before. Here is an almost-too-thin Perkins exiting a shower with a noticeably lowered waistline on his swimsuit, now revealing just a hint of tanline. (*Corbis*) *inset:* Another meatier, fair-haired version of the screen badboy was NICK ADAMS (*b.* Nicholas Adamshock, July 10, 1931, Nanti-coke, Pennsylvania. *d.* 1968). Where Perkins would use his brains as a way of menacing his adversaries, Adams used his brawn. As beefier fellows go, chest hair added to his air of masculinity, whereas Perkins's smooth exterior and lean frame made him appear just this side of fey. (*Corbis*)

A male body for the ages. *PAUL NEWMAN* (*b.* January 26, 1925, Cleveland, Ohio), whose career began in earnest in the fifties, became *the* box office champion of the sixties. He was the perfect blend of physical tastes for both the youth and mature moviegoing audiences. Pretty enough to serve as a treat to the teen crowd, he was intelligent enough in his film-work to hold the attention of more discriminating older fans (which is not to say that they could not also appreciate his good looks). Possessing an almost perfect body, Newman's lean, muscular, tanned physique set a standard for male bodies that was rarely if ever equaled, let alone surpassed. Of his dozens of films, many offer glimpses of what some could call a body sculpted by some divine being, but I suggest *Sweet Bird of Youth* (1962) as the perfect vehicle to encase his golden-boy beauty. It doesn't hurt that he plays a male gigolo in the movie either. This still is from a film aptly titled *The Prize* (1963). (*Kobal*)

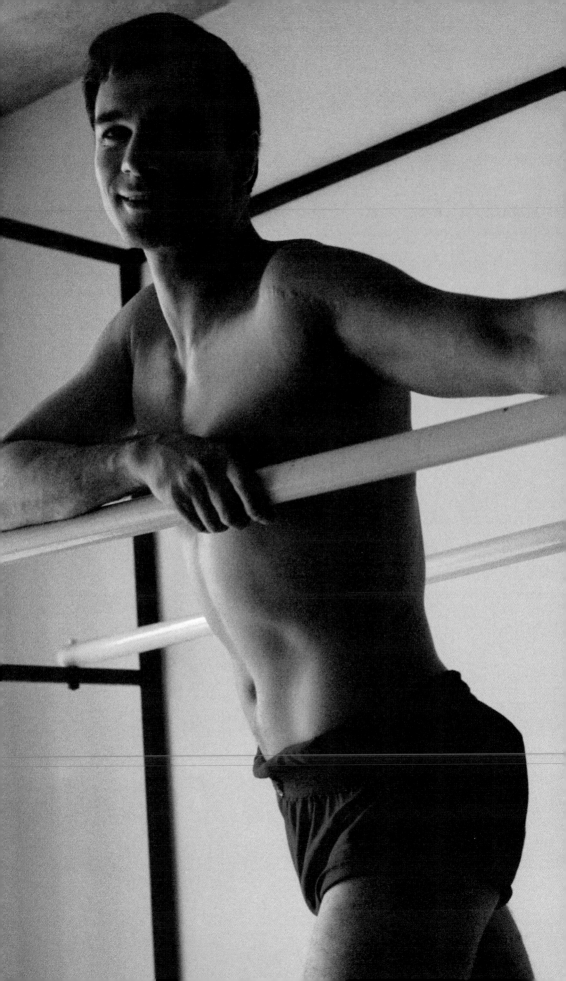

Newman may have set the standard, but that hardly meant other leading Hollywood men were going to get caught with their pants down (oh, but that we could have hoped they would!). Modern-day bodybuilding, which began to take a foothold during World War II, slowly worked its way into the daily routines of the populace of Hollywood male stars, becoming an obsession in the sixties. With everyone jumping on the youth bandwagon, younger and older stars alike felt the pain in order to gain the attention of the public, which was expecting more from the bodies of Hollywood's masculine idols. So, gone were the medicine balls and jump ropes of yesteryear. Replacing them were barbells and dumbbells, and a satisfyingly increased focus on overall tone and musculature—as opposed to simple girth and breadth.

this spread: GEORGE MAHARIS (b. September 1, 1928, Astoria, New York.) One of the first leading men to outwardly embrace the new workout ethic was Maharis, whose iron-pumping routine worked in his favor, possibly just in terms of his body. He never actually became as big a star—see *Exodus* (1960)—as his lean, well-muscled exterior would have handled. It was not the first time, nor would it be the last, that a beautiful male face and body would prove something of a hindrance in terms of achieving acting success. (*Wallace Seawell/MPTV*) *right: CLINT EASTWOOD* (b. May 30, 1930, San Francisco.) Another gent who also proudly extolled the virtues of a trip to the weightroom, luckily, did not seem to suffer one iota from the attention he gave to his body. Possibly he just had better management. Regardless, early in Eastwood's career he was as well known for his pretty-boy looks and slim physique as he was for his acting. To his credit, as he matured—for instance in *Dirty Harry* (1971)—his looks mutated into a more machismo version of his former self. By the seventies, he became an American male icon. (*MPTV*) By the way, not only are the navels showing in both pictures, but it looks like Maharis has attempted to expose even more of his lower torso by forcing down the waistline of his already short shorts. Naughty boy! But what a nice derriere!

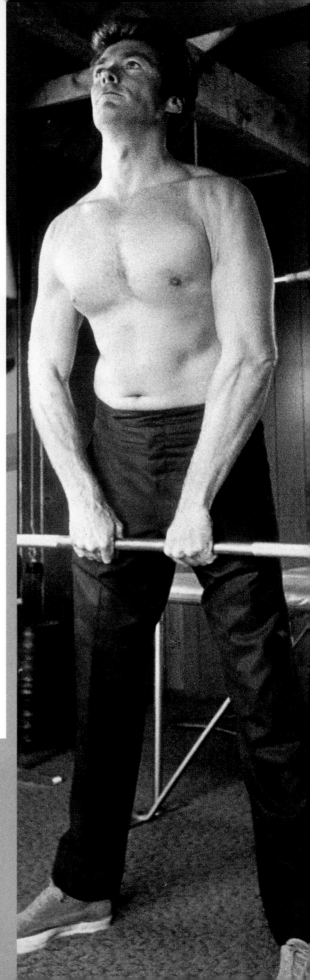

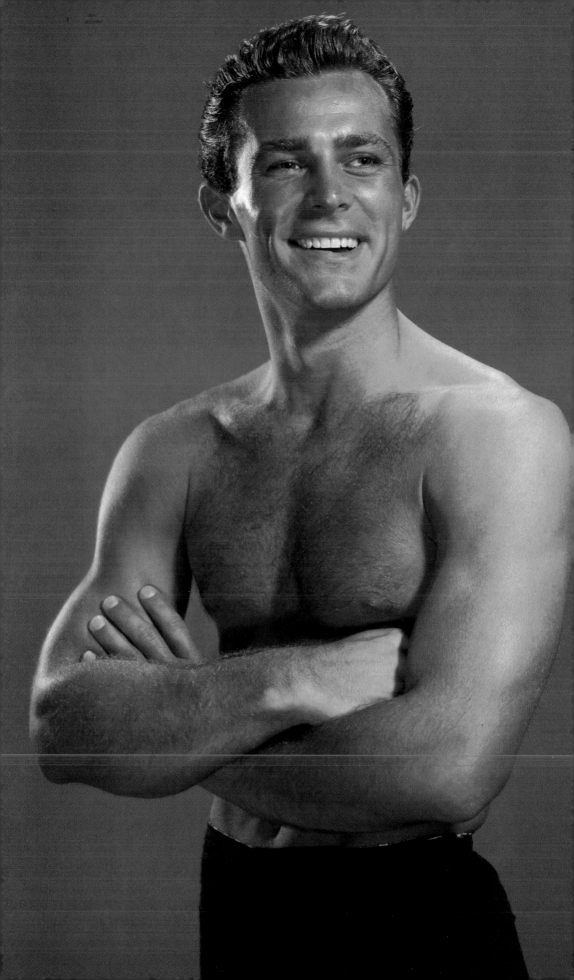

If Paul Newman had a rival in the perfect body department, I would submit ROBERT CONRAD (*b.* Conrad Robert Falk, March 1, 1935, Chicago) for consideration. Though naysayers will quibble that his splendid physique benefited because of his lack of height—actually five-foot-eight—I defy anyone to offer a more well-proportioned specimen of male muscular magnificence. A onetime boxer and singer! (see above from Author's collection), Conrad enjoyed only marginal success on film—see *Palm Springs Weekend* (1963)—but became something of a household name with his two television series *Hawaiian Eye* and, of course, *Wild, Wild West.* Another plus in Conrad's favor: he was and remains a proponent of physical fitness through routine exercise and diet. He was also one of the first male stars of any stature to be well thought of for the pride with which he showed off his magnificent body. Viva le Conrad! (*Photofest*)

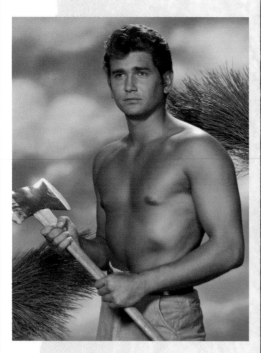

Did I imply that the he-man physique of yesteryear had disappeared in the sixties? I hope not, because nothing would be further from the truth. What happened was, he too benefited from a more precise workout and came out looking ever more streamlined (and I might add, sexy). Here are two good examples: one for the soda-pop set and one for the cocktail crowd.

inset: MiCHAEL LANDON (*b.* Eugene Maurice Orowitz, October 31, 1936, Forest Hills, Queens, New York. *d.* 1991.) Television's Little Joe Cartwright in the unfathomably popular Western series *Bonanza,* Landon first came to fame as the lead in *I Was a Teenage Werewolf* (1957). Though film stardom eluded him, brawny-lad Landon could easily console himself in his lengthy success on the small screen, following *Bonanza* with *Little House on the Prairie* and *Highway to Heaven.* (*Corbis*) *this spread:* CLiNT WALKER (*b.* May 30, 1927, Hartford, Connecticut.) In terms solely of physical presence, Walker was enormous. Possibly no other male star, from the silents to today, exuded such massive manliness. Looking for a "daddy"? Look no further (as if you could see past him!). The best of what Walker had to offer was the balance of relative slimness in the right areas, which gave him an almost too-perfect "V" silhouette (check him out in *None but the Brave,* 1965). To top it off (literally), he possessed an ample amount of chest and body hair (and a Brycreem-groomed haircut). As if there was any question about his virility. Yes, sir! (*Photofest*)

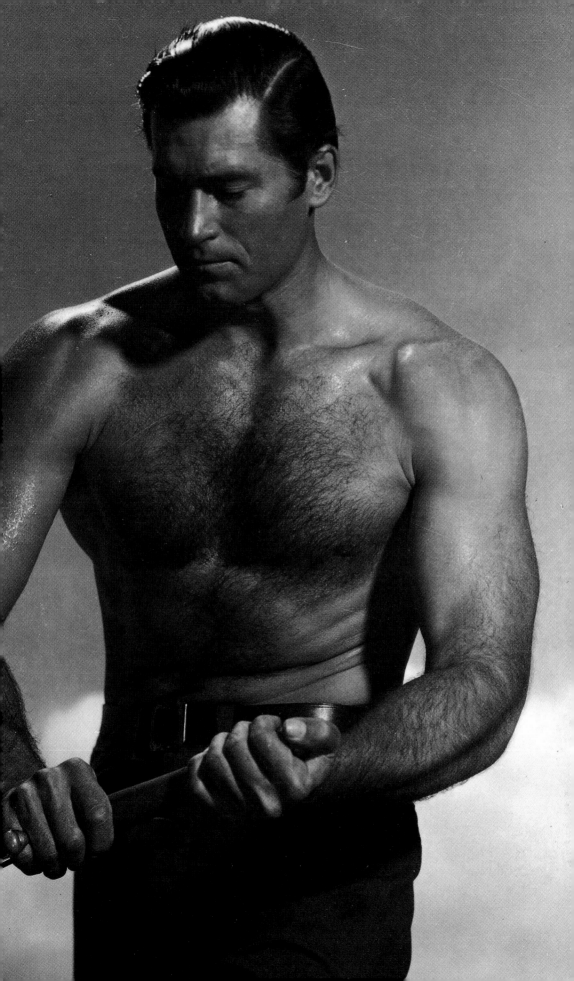

Another one of my personal favorites (and I'm guessing one of yours, too) was rugged and randy *ROD TAYLOR* (*b.* January 11, 1929, Sydney, Australia). His career began in the mid-fifties (billed as Rodney Taylor) but hit the big time in the sixties, most memorably in Alfred Hitchcock's *The Birds* (1963) and most handsomely in *The Time Machine* (1960). Taylor was the epitome of the physically dominant male hero rescuing those in distress. In many ways he harked back to an earlier era, when sheer brute force equaled righteousness. Fortunately, because films of the sixties were less inclined to be chauvinistic, Taylor's testosterone level was kept on low. Incidentally, when scanning archives for shirtless men, I happened to encounter quite a few "bow and arrow" publicity shots, especially from the forties to mid-sixties. Presumably, the male subject of a photo often doesn't know what to do with his hands; it seems an archer's bow was an easy remedy. Nevertheless, the impression of a husky hunk with an arrow at the ready was highly sexually suggestive whether intended or not. (*MPTV*)

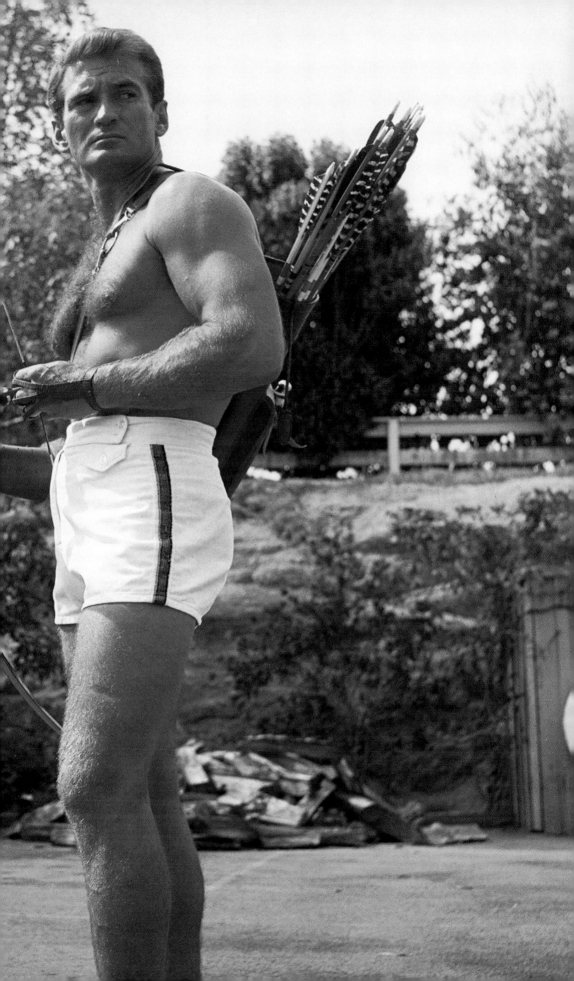

If hirsute leading men scratch your itch then you have only one man to thank: *SEAN CONNERY* (*b.* August 25, 1930, Edinburgh, Scotland). When Connery appeared shirtless as James Bond in *Dr. No* (1962), hairy-chested men finally gained the respect they deserved. Prior to this, hairy men of the screen still appeared somewhat brutish (though more masculine and mature than their smooth, boyish rivals). Even more enticing, Connery's chest hair grew in a discernible swirling pattern around his pectorals, converging downward into (please forgive my momentary digression!) what has become known in tawdry circles as a "goody trail" (which you can get a slightly better view of on page 149). This made his appearance seem more sexy than savage. A onetime champion bodybuilder (Mr. Scotland) and swimsuit model, Connery remains a virile leading man. (*David Sutton/MPTV*)

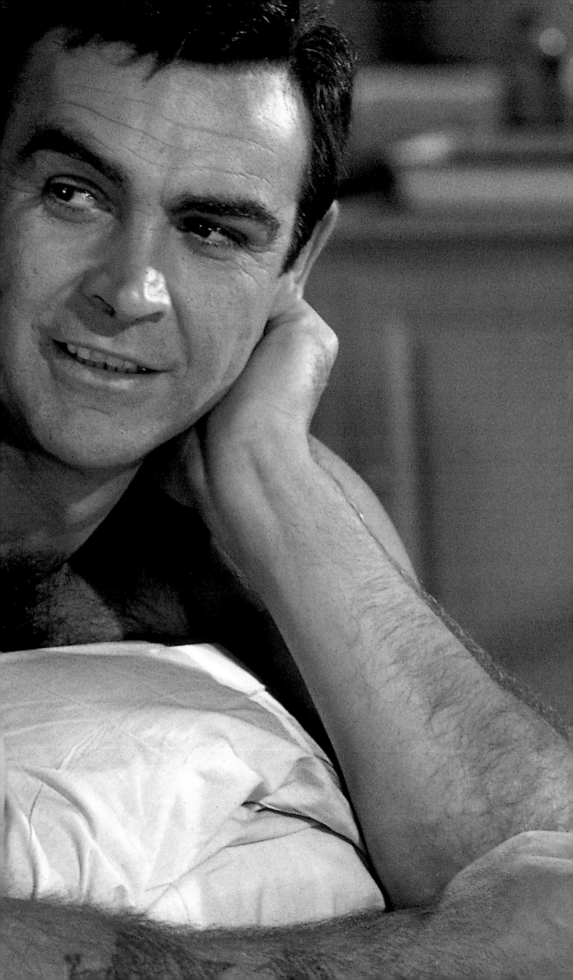

Before the decade's end, the taboo of total male nudity in legitimate film was finally shattered. Here are a few of the reasons why: the end of the Code in 1968, replaced with the Motion Picture Association of America (MPAA) ratings system; the great generation gap, which reached its widest divide during the late sixties; and a change in postal regulations that allowed the transport of male nude photography through the mail in the mid-sixties (basically, decriminalizing the act of mailing gay pornography). Bravo!

this spread (pardon me!): The best visual example I can give of the new body bonanza is splendid LEONARD WHITING (*b.* June 30, 1950, London, England) in the 1968 version of Shakespeare's *Romeo and Juliet.* Director Franco Zefferelli knew the time

was right to shift the focus from Juliet (Olivia Hussey) and languish it on the well-formed backside of Romeo (Mr. Whiting). (*Kobal*) *left:* In contrast to the romanticized representation of the male body in *Romeo* was the seedy display it was afforded in the nevertheless memorable flick *Midnight Cowboy* (1969). This X-rated film made *JON VOIGHT* (*b.* December 29, 1938, Yonkers, New York) a star, but did little to further the acceptance of male (or female) screen nudity beyond sheer sensationalism. (*Kobal*) *right:* The close of the sixties also saw the temporary rise of the black male star as "sex symbol." *JIM BROWN* (*b.* February 17, 1935, St. Simons Island, Georgia), unlike his predecessors Belafonte and Poitier, exuded measurable sexuality in his roles. Unfortunately, his films did not prove popular enough with a (white) mainstream audience. It was not until the nineties that the film industry recognized there was enough of a black moviegoing audience to justify high-profile productions starring blacks in lead roles. Film still from 1969's *100 Rifles*. (*Kobal*)

With free love in full swing, the stage was set for the sexy seventies. If there ever was a time of flux, it was during the decade of disco. Cultural movements—women's, blacks', gays'—further rendered the male body leaner, even less physically aggressive than before. At the same time, it began to show up in more places—books, magazines, television, advertisements, and films. But the relative acceptance of the male body as a cultural icon came with a price. Whatever aesthetic advances were made with his introduction, they were countered by a conservative backlash. Fortunately, though this may have caused him to stumble in his platform shoes, he kept dancing forward.

The epitome of the sexy seventies male could be characterized in one word: trade. (The word is a not-too-slightly derogatory term used in gay culture.) He would be thin, but quite muscular, palpitatingly attractive, with a set of bedroom eyes, and given to a certain amount of sexual promiscuity. Could anyone fit that description better than *JAN-MiCHAEL ViNCENT* (*b.* July 15, 1944, Denver, Colorado)? A level of pure, unavoidable lust permeated from Vincent, even in the most benign roles, including Disney's *The World's Greatest Athlete* (1973). But, despite the success suggested by early indications of super "sex symbol" status, this ripped-and-cut baby-blue-eyed beachcomber was not able to hold fame together long enough to fulfill initial promises. (*Michael Ochs Archives*)

THE SEVENTIES:
SLIM, SEXY, AND SO-O-O-O AVAILABLE

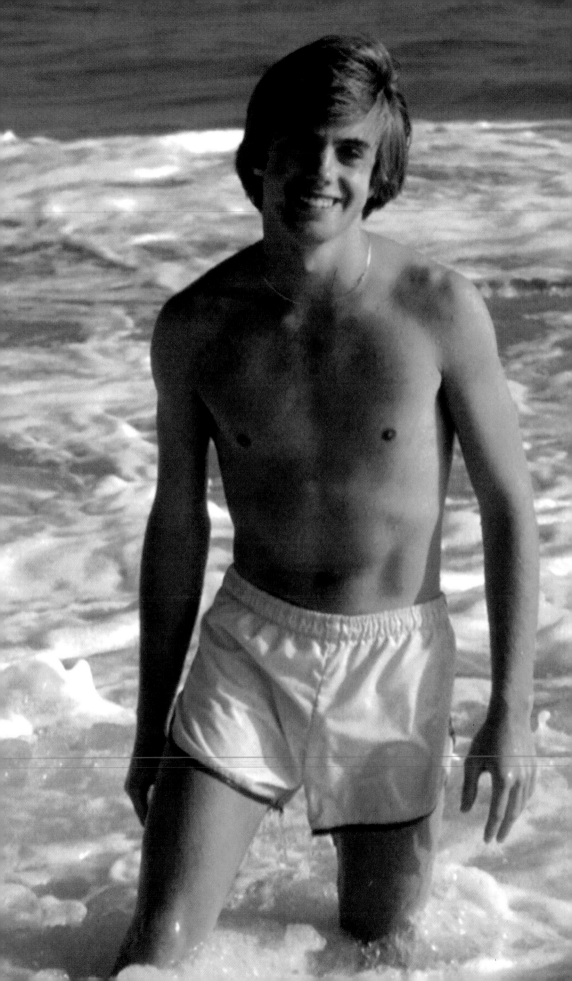

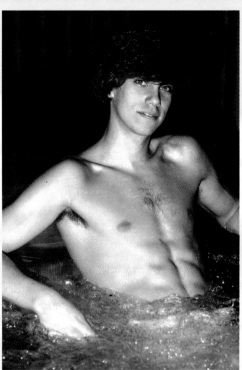

From the late fifties onward, each decade yielded its own crop of teen idols, and the seventies saw this field grow quite fertile. By decade's end, little hunklets were everywhere, and, as it was twenty years before, fans couldn't get enough. By the way, does anyone else notice that these two boys, *er* men, are wearing white swimsuits? Didn't anyone tell them what happens when a white swimsuit gets wet?

this spread: SHAUN CASSIDY (b. September 27, 1958, Los Angeles) parlayed his mop-top talents into wealth and success. Son of actress Shirley Jones and stepbrother to that other teen heartthrob David Cassidy, Shaun, like his compatriots, was measurably more sexual in his demeanor than any of the earlier decade's teen idols. His body was also, though by no means huge, markedly more muscular—and shown frequently in concert. Using the body as sexual bait was now a part of the total package, where before it was kept under wraps. *inset:* ROBBY BENSON (b. Robert Segal, Janury 21, 1956, Dallas), a brunette version of Cassidy (though their actual careers had little in common). Benson began his career at a very early age, appearing in commercials by age three. Once he arrived in his late teens, he looked exactly like what a teenager in the seventies was supposed to look like: thin, tousled hair, big-eyed, and laid-back. Earlier photos of Benson showed little sign of muscular development, but by the time of this rather provocative Jacuzzi setup, there is noticeable definition. The seventies teen male was even more susceptible to unrelenting body self-awareness and scrutiny. (*both images from Michael Ochs Archives*)

A s if the previous two dudes weren't enough to ponder, here is a teen idol duo just barely out of adolescence to push the envelope (or, judging by the bulges, make that the crotch). Ah, unabashed youth!

this page: SCOTT BAIO (b. September 22, 1961, New York City.) Better known as Chachi from *Happy Days* or Charles from *Charles in Charge*, Baio did not seem hesitant off the set in showing—as near to it as he could without being censored—that he was all man (well, at least a very young one). He also, at around age sixteen, was no stranger to working out (although, by the nineties his timidly toned physique would easily be eclipsed). *right:* JIMMY MCNICHOL (b. July 2, 1961, Los Angeles.) Brother of Kristy (from *Family* and *Empty Nest*), McNichol began an acting career that never made it off the ground. Possibly he tried too hard (or allowed himself) to be seen as a boy toy, when he should have thought more about the rules of the game. In his time, as it was before and has been since, when an actor is looked upon more for his physical attributes than for his acting skills, his career will likely suffer. Period. Too bad, because as far as the "twinkie" look goes, Jimmy sure had the role down pat. (*both images from Michael Ochs Archives*)

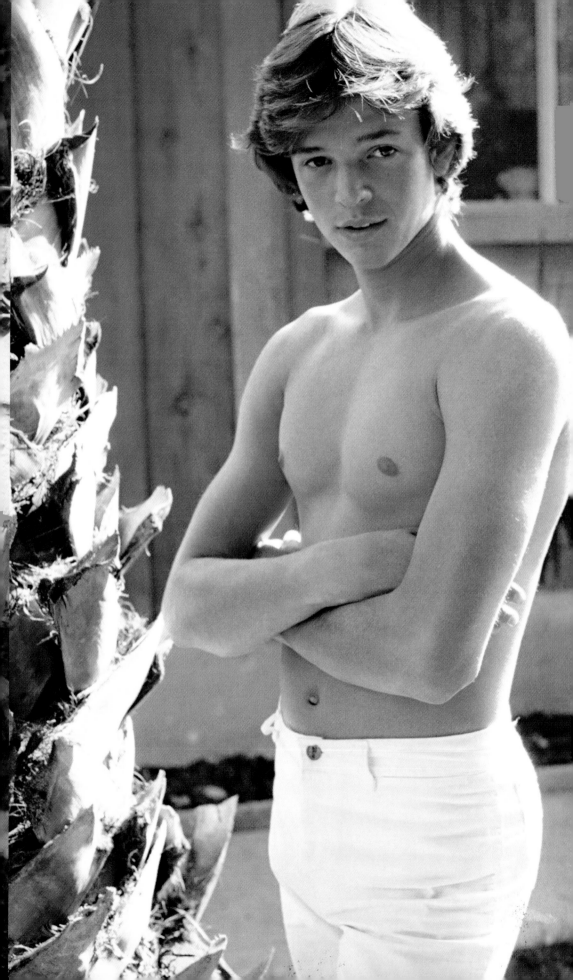

What truly went AWOL in the seventies—along with body fat—was the really *big* male star. By big I mean men the size of Clint Walker or Victor Mature. Remember, the seventies was the time of a more non-aggressive physique (though readily accessible, sexually). A *largesse* body was too intimidating. What we found in its place were modified versions of earlier *uber*masculinity, and, in some cases, as I believe is evident on this spread, some rather fabulous offerings.

left: TIM MATHESON (*b.* December 31, 1947, Glendale, California) was the type of cute male lead who would continually pop up, either in television or film, beginning with the late sixties, up through to the present day. And he has remained as handsome and fit from then to now. *right:* GREG EVIGAN (b. October 14, 1953, South Amboy, New Jersey.) Starring opposite a chimp early in his career—in *B.J. and the Bear*—may have been a poorly thought-out move. Regardless, Evigan was as cute and well built as they come. Just hairy enough to suggest "mannish" traits, he was also lean enough to be more plaything than playboy. And what about those blue-green eyes set off by that fire-engine red Speedo? Woof! (*both images from Michael Ochs Archives*)

100

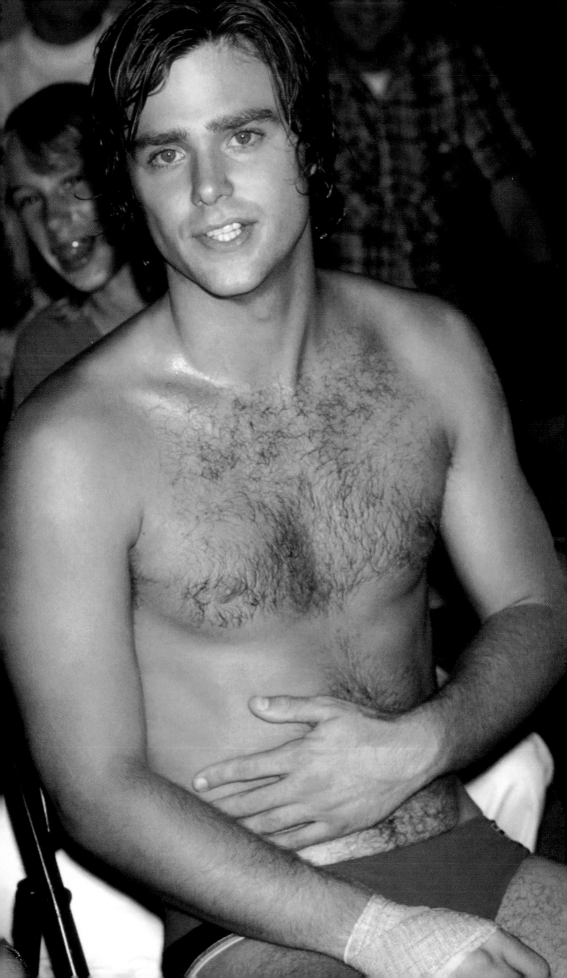

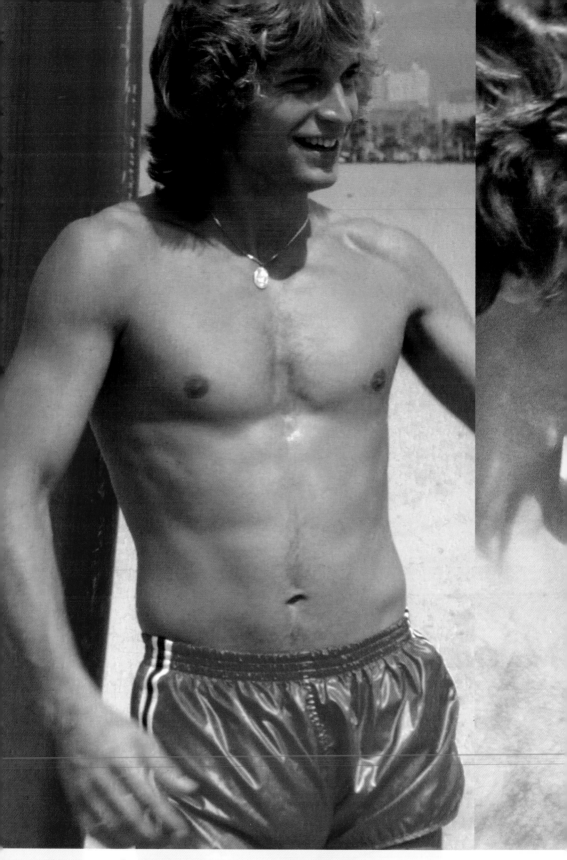

above: *REX SMITH* (*b.* September 19, 1956, Jacksonville, Florida) of "You Take My Breath Away" song fame was seen recently on Broadway in *The Scarlet Pimpernel*. (*Michael Ochs*) *near right:* *PARKER STEVENSON* (*b.* June 4, 1952, Philadelphia) went from *Hardy Boys* innocence to "big one" notoriety (thanks to a disclosure by then-wife Kirstie Alley). Unfortunately this photo does nothing to

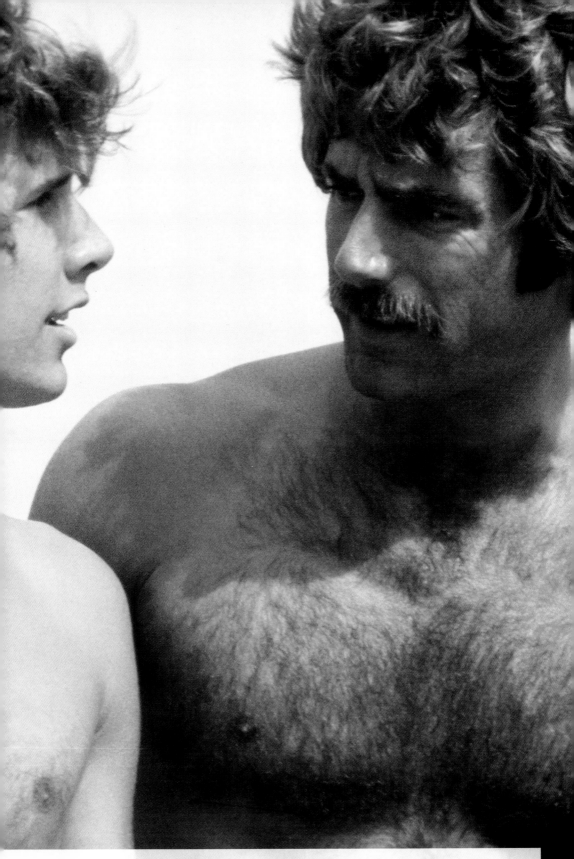

satisfy one's curiosity. *far right:* A seventies entry into the "manly man" category: *SAM ELLiOTT* (*b.* August 9, 1944, Sacramento, California). Elliott's film *Lifeguard* (1976)—abundant in terms of glimpses of male flesh—was dominated by his super bod and Castro Street–style moustache. Can you name the last time you saw a lead male star with one of those? (*Kobal*)

A carryover from the sixties into the seventies with every hair in place, *BURT REYNOLDS* (*b.* February 11, 1936, Waycross, Georgia) inherited the baton of favored furry male (*Deliverance*, 1972). But Reynolds took his bearish countenance one step further by posing nude, albeit with genitals modestly covered, in a very early seventies edition of *Cosmopolitan* magazine—thus heralding in a new era of male body worship. But take note of Reynolds's career, which floundered for many years until he did agree to appear in the altogether nude. Such post-neo-porn success for men is quite, quite rare. Thus, the majority of today's male stars, regardless of how beautiful their bodies are, choose not to bare all, or even part, of their physiques for the printed page. However, they will often drop their drawers for dramatic integrity onscreen. The reason for this dichotomy? A photo is considered fixed and can be too easily disseminated among the masses, while the moving image (of bare buttocks) is considered elusive and momentary. (*Kobal*)

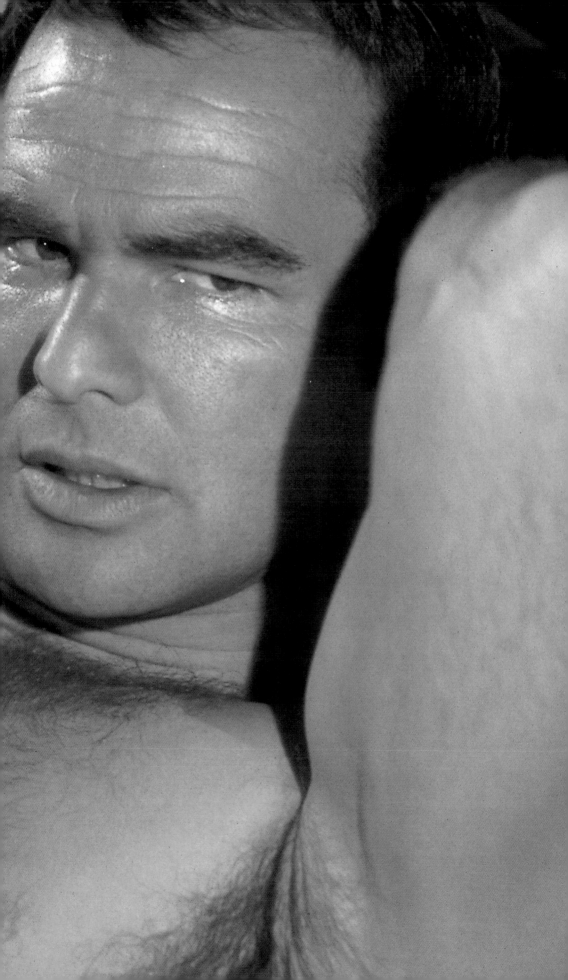

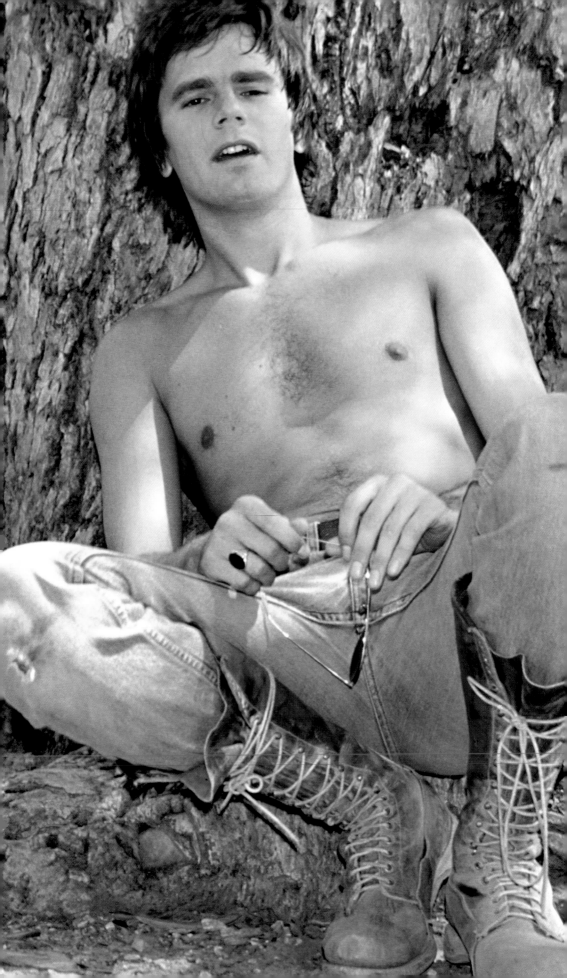

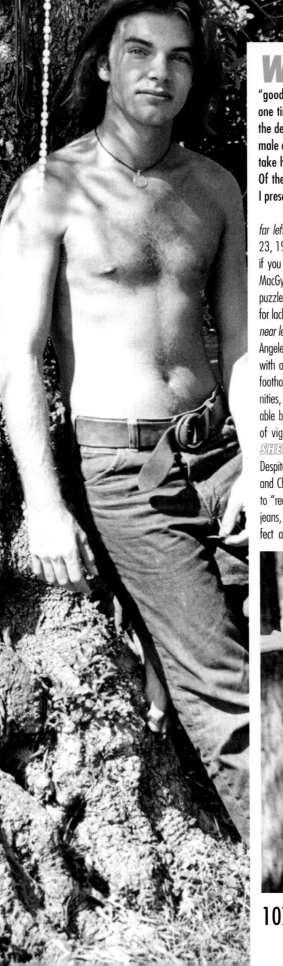

What the seventies may have lacked in sophisticated leading men, it made up for in the guise of the "good-ole-boy," just-off-the-farm antihero. It seems at one time or another, every major (or minor) male star of the decade played at least one homespun role. The type of male character lead that you would not, necessarily, like to take home to mother—unless you lived in a trailer park. Of the great plentitude of unwashed seventies homeboys, I present these three.

far left: RICHARD DEAN ANDERSON (b. January 23, 1950, Minneapolis, Minnesota.) Yes, the one and the same, if you can believe it. How one can go from this to television's MacGyver? Although the charm of a lackadaisical manner is a puzzle, it seems the appeal of the cute, shirtless bumpkin is—for lack of a better term—inbred for many of us. (*Michael Ochs*) *near left:* EDWARD ALBERT (*b.* February 20, 1951, Los Angeles) Son of acclaimed actor Eddie Albert, little Ed started off with a bang in *Butterflies Are Free* (1972) but never gained a foothold in the hurly-burly of Hollywood. Despite his poor opportunities, his barefoot and carefree attitude paired with a very workable body and unbelievably pouty lips earned him the attention of vigilant boywatchers. (*Michael Ochs*) *inset:* MARTIN SHEEN (*b.* Ramon Estevez, August 3, 1940, Dayton, Ohio.) Despite being an accomplished actor, this father of Emilio Estevez and Charlie Sheen had an edge to him that was perfectly suited to "redneck" sensibilities (*Badlands*, 1973). Put him in a pair of jeans, leave off the shirt, hand him a rifle, and you have the perfect antisocial stud. (*MPTV*)

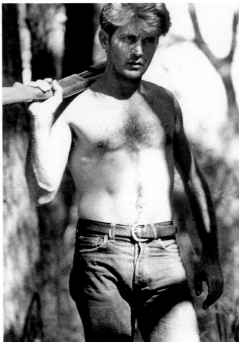

My vote for perfect diamond-in-the-rough dude would go to this choice cutlet. MATT DiLLON (*b*. February 18, 1964, New Rochelle, New York) was "discovered" at age fourteen and cast in his first role in *Over the Edge* (1978). Coming in on the heels of the seventies, he made his mark in the eighties, but not before inspiring adulation among the throngs for his "wrong-side-of-the-tracks" allure and perfectly honed, post-adolescent, but still very young adult body. Take a look at him with his shirt completely off on the closing endpaper (taken just about a year later) for an even better example of his bodily charms. Here, his hair is kept long; there, the style was shorn for the advent of a new decade. The choice is yours. (*Michael Ochs*)

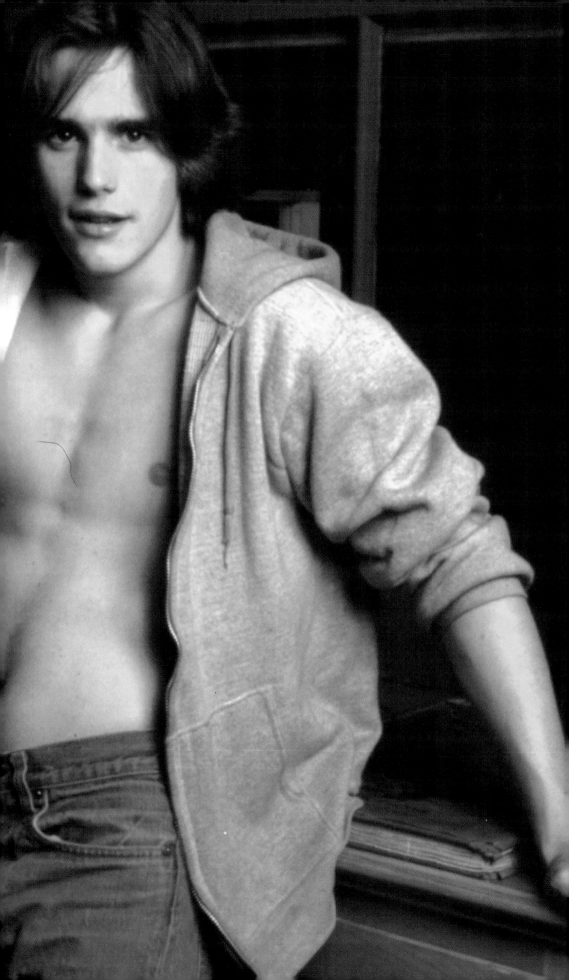

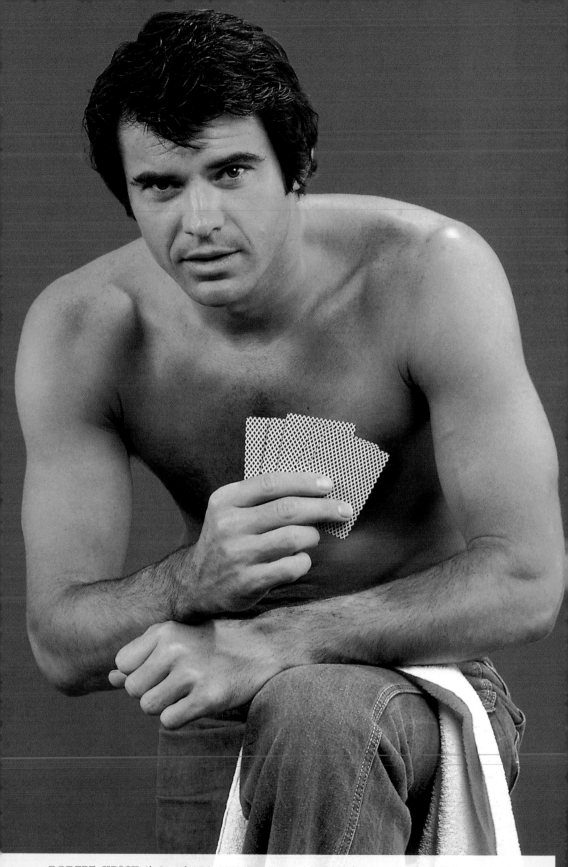

ROBERT URiCH (*b.* December 19, 1946, Toronto, Canada.) This six-foot-two college football player got his big break thanks to Burt Reynolds. He became a well-known television star with his two hit series *Vega$* and *Spenser: For Hire*. Admirably, he defeated cancer to take the helm of the updated version of *Love Boat*. (*MPTV*)

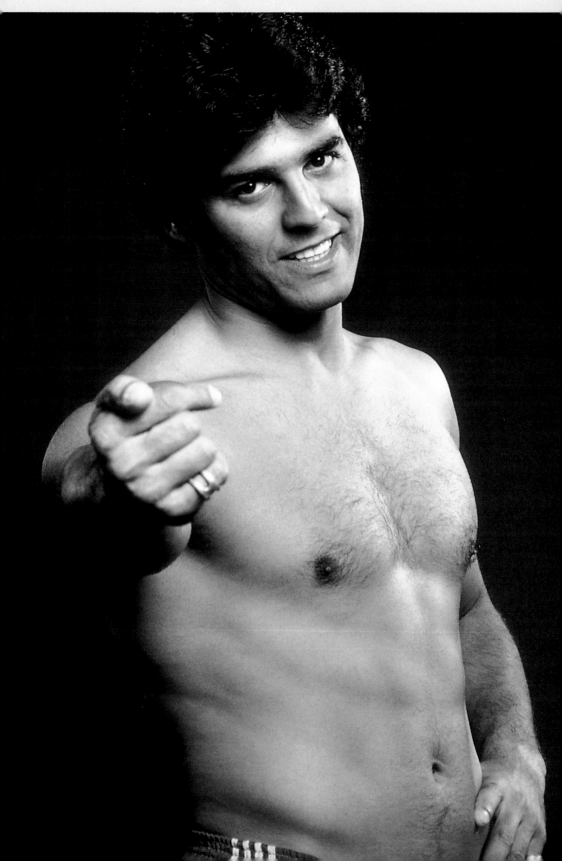

Few, if any, new film genres in the beefcake sweepstakes held as much bounty as the seventies martial arts movie. Via the outstretched limbs of *BRUCE LEE* (b. Lee Yuan Kam, 1940, San Francisco. d. 1973), the kung fu craze took the world by storm. Aside from offering ample opportunity to watch countless shirtless men relentlessly whack each other's bodies, these films marked the first time that an Asian man was afforded the lead in a string of successful motion pictures. Sadly, Lee's good fortune (which came after years of toil) was shortlived. He died quite unexpectedly while filming *Game of Death* (released six years posthumously in 1979). Lee's costar in the film pictured (*Return of the Dragon*, 1972) featured an Anglo actor, *CHUCK NORRIS* (b. 1939, Ryan, Oklahoma), who now, after years of marginal film success, is firmly ensconced in his own television series, *Walker, Texas Ranger*. (*MPTV*)

If catching glimpses of the male body was made into a contest and you were looking to quickly accumulate points, what could reap faster rewards than an all-guy shower scene? Whether in a prison camp (*Cool Hand Luke*, 1967) or here, after a round of manly exertion (*Rollerball*, 1975), no fleeting moments on film can get you more fired up than a soapy, steamy interlude.

JAMES CAAN (*b.* March 26, 1939, Bronx, New York.) With his formidable square shoulders and thinning pate, Caan became a top star of the seventies—an Oscar nod for *The Godfather* (1972)—but saw little action in the eighties. He reemerged as a character lead in the nineties. (He was, however, at his cutest, and most menacing, in 1964's campy *Lady in a Cage* opposite Olivia De Havilland.) (*Kobal*)

A h, the eighties! What a splendid time of social schiz-
ophrenia. The incoming Reagan-Bush regime was so
resolute in repairing the damage done by the more "sensi-
tive" outgoing Carter administration that it felt the need to
enforce its agenda with an army of conservative super-
men. Ironically, this towering tableau of testosterone only
heightened the touchy issue of male sexuality and desir-
ability. Always remember gentlemen, be careful what you
ask for.

inset: SYLVESTER STALLONE (*b.* July 6, 1946, New
York City.) After gaining worldwide fame and acclaim as *Rocky*
(1976), Stallone's box office appeal and physique grew and
grew. By the eighties, he, along with "Ah-nuld," became the
two *pec*-tacular pillars of the Hollywood film community. Stal-
lone was never one to abstain from showing off his body—on
display in nearly all of his films. His steely frame was possibly
most memorably seen in *Demolition Man* (1993). Why?
Because he was nearing fifty and still holding up astoundingly
well. (*Photofest) this spread,* from *Red Heat* (1988):
ARNOLD SCHWARZENEGGER (b. July 30,
1947, Graz, Austria.) A top bodybuilding champ from the late
sixties (no surprise there!), Arnold parlayed limited acting skills
and his inescapable accent to become an all-time box office
champion, too. Beginning with *Conan the Barbarian* (1982),
his massive shoulders effortlessly hoisted the revenues of a
dozen expensive productions into the stratosphere. However, by
the nineties, the size of this superhero's haul would quickly lose
heft. (Doubtless, with the already enormous size of his bank
account, he's hardly lost sleep!) (*Everett*)

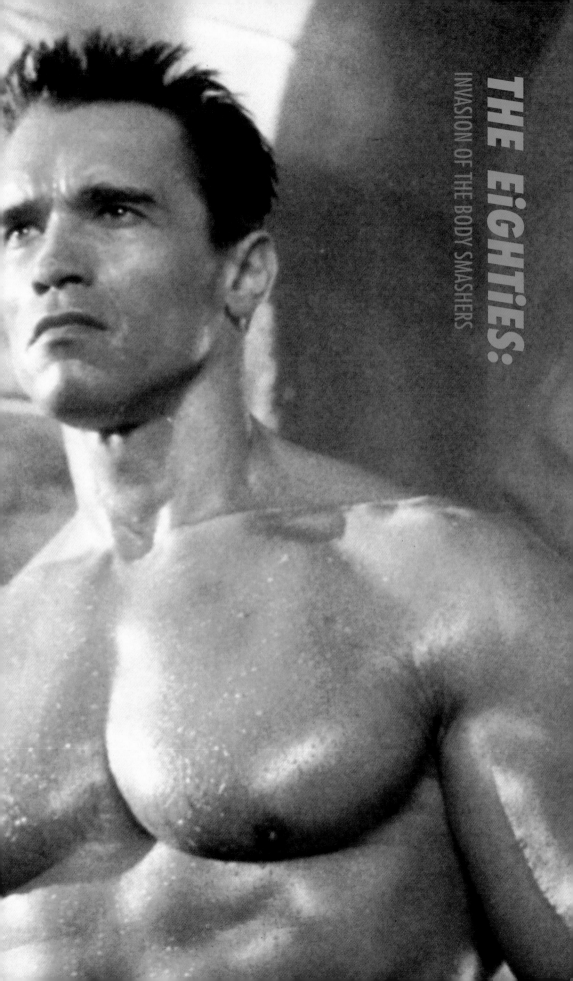

While the body of the seventies disco dude leaned in one direction, an interesting glitch in the system of the eighties allowed for the formerly slightly built to amass muscle at the gym and "supermen" to go gay on film. So, while the conservatives thought they were banishing wimps from our midst, alternatives were undermining the course of the straight- and narrow-minded.

inset: JOHN TRAVOLTA (*b.* February 18, 1954, Englewood, New Jersey.) Fame for his primping in front of the mirror—wearing diminutive black briefs—in *Saturday Night Fever* (1977) did nothing to dissuade Travolta from feeling anxious when the eighties rolled around. The only positive aspect to come from *Stayin' Alive* (1983)—the ill-conceived sequel to *Fever,* shown above—was Travolta's newly wrought body. If anything, it showed (limited) audiences what was possible to do with one's body if you put your mind, money—and the aid of Sylvester Stallone—to it. (*Kobal*) *this spread:* CHRISTOPHER REEVE (*b.* September 25, 1952, New York City.) Already perfectly honed for his star-making turn as *Superman* (1978), Reeve took a great commercial gamble by playing the sinister gay lover in the film adaptation of *Deathtrap* (1982). One could not decipher if the audience's squeals were for his beautiful torso (which he did not show in *Superman*) or, more likely, for his onscreen smooch with costar Michael Caine. Though the film was far from a box office success, it did not harm Reeve's career, though his tragic accident in 1995 did—resulting in partial paralysis. Nonetheless, he is still a marvelously attractive fellow and great all-around gentleman. (*Everett*)

118

*T*hanks largely to a show of interest by women, the eighties also saw the emergence of the celluloid male as pure plaything. However, the average male citizen still considered overt attention to one's own body as a vain, shallow undertaking, and slightly suspect—nothing a "real" man would lavish time on. But all that disdain would soon become a thing of the past, once the fairer sex demanded that men "get physical." On the small or large screen, this boy toy's self-absorbed existence was, by and large, tolerated so long as he fulfilled the fantasies of others. Amusingly, just as it was for women, the blonder the man who preened over every pore of his body, the more vacuous he was thought to be.

Perhaps no other form of entertainment is more responsible for the proliferation of male babes than the classic daytime/evening soap opera. *inset:* jACK WAGNER (*b.* October 3, 1959, Washington, D.C.) A golf enthusiast, Wagner set hearts aflutter in *General Hospital,* then, years later, plucked at heartstrings again in the turgid evening melodrama *Melrose Place* (a cesspool for many a choice male). Also a top-ten singer, with "All I Need." (*Everett*) *this spread:* DOLPH LUNDGREN (*b.* 1959, Stockholm, Sweden.) Lundgren was *the* pretty-boy gargantuan of eighties action flicks. But his seemingly perfect exterior makes him too easy to dismiss; he is the holder of a degree in chemical engineering. Still a contender in the nineties and beyond, he was first seen as Sly Stallone's Russian adversary in *Rocky IV* (1985). (*Corbis/LGI*)

120

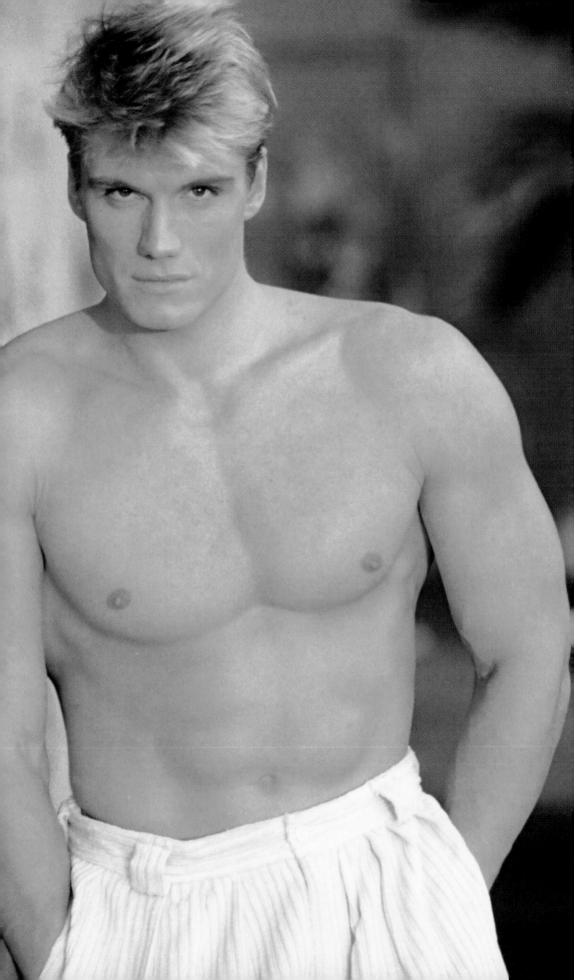

Not to be pushed aside by their golden-haired brethren, many a raven-haired male quickly lost their shirts (if not more) in their quest to find fame, glory—and the fawning fan.

inset: ROB LOWE (*b.* March 17, 1964, Charlottesville, Virginia.) Fame came quickly to this possibly too-pretty member of the infamous eighties "brat pack," but could just have easily evaporated after his run-in with the law—via his notorious sex videotape. Age has somewhat mellowed his once disarming looks—arranged for fine viewing in this still from the 1988 film *Masquerade* (and doesn't he look inviting in his baby-blue boxers and white sweatsocks?)—allowing him to play more demanding roles in film and, most notably, on television's *The West Wing.* (*Everett*) *this spread:* RICHARD GERE (*b.* August 31, 1949, Philadelphia.) Though his career began to bud during the late seventies, it came into full bloom with the 1980 film *American Gigolo* (in a role originally slated for John Travolta or Christopher Reeve). The film also marked a milestone for men in films: an entire motion picture revolved around the private and professional indulgences of the self-centered male protagonist (what gigolo isn't self-centered?). This included his much-lauded Armani wardrobe and an exercise routine that involved inversion boots (where did you put yours?). Gere's status appeared shaky in the late eighties but rebounded nicely with *Pretty Woman* (1990). Today, age has only heightened his attractiveness, especially for lovers of gray-haired guys. Still from *Yanks* (1979). (*Kobal*)

123

If you like your men somewhere in the middle—between too pretty and too empowered—here's a pair of beefy bookends to ponder over.

this page: LORENZO LAMAS (*b.* January 20, 1958, Los Angeles.) In the looks department, it certainly worked in Lamas's favor to have such attractive parents—Arlene Dahl and Fernando Lamas. A handsome part of the television casts of *Falcon Crest*, *Renegade*, and *Air America*. (*MPTV*) *right:* JON-ERiK HEXUM (*b.* November 5, 1957, Tenafly, New Jersey. *d.* 1984.) Death by accidental gunshot robbed us of the chance of knowing how far Hexum's beautiful body would have taken his career. Few opportunities come up to see him at work, but his telefilm *Making of a Male Model* (1982) is his most notorious appearance. (*Michael Ochs*)

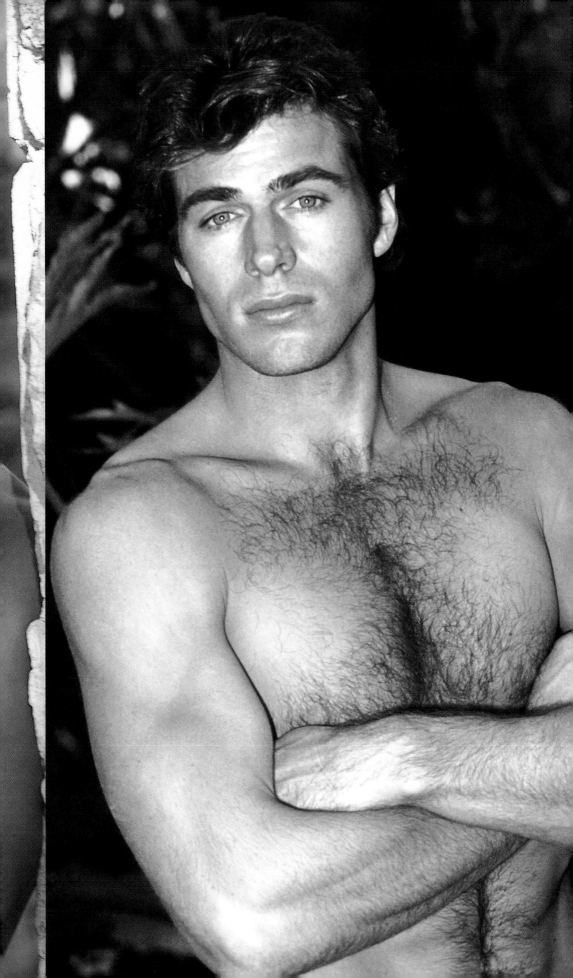

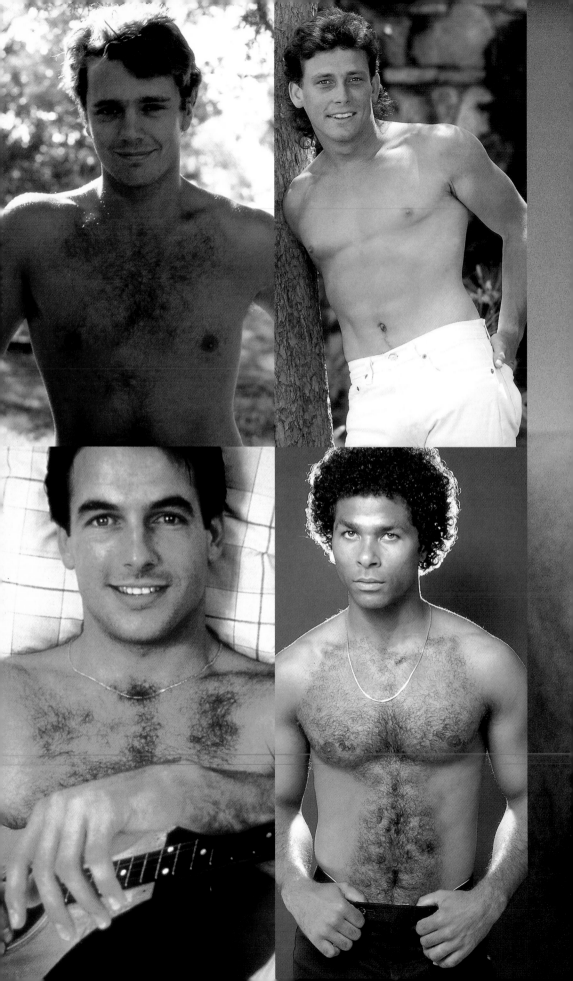

Though by most accounts, primetime television in the eighties held little merit, it did prove an abundant source of muscled men. *clockwise from top left:* JOHN SCHNEIDER (*b.* April 8, 1980, Mt. Kisco, New York.) This six-foot-three "country boy" found favor as Bo Duke, opposite Tom Wopat, in the long-running series, *The Dukes of Hazzard.* (*Kobal*) WILLIE AAMES (*b.* July 15, 1960, Los Angeles.) Adorable "Buddy" opposite Scott Baio in *Charles in Charge.* Today, believe it or not, he is a children's pastor! (*MPTV*) TOM SELLECK (*b.* January 29, 1945, Detroit.) A bit of a dichotomy: Selleck will play a gay man in *In and Out* (1997), but fiercely defend his NRA affiliations. Became a celebrity with *Magnum, P.I.* (*MPTV*) PHILIP MICHAEL THOMAS (*b.* May 26, 1949, Columbus, Ohio.) Don Johnson's partner in *Miami Vice*, and the one most likely, therein, to be seen shirtless. (*Photofest*) MARK HARMON (*b.* September 2, 1951, Burbank, California.) A college football hero, whose star wattage never lit things up beyond the small screen, but still most memorable in *St. Elsewhere.* (*Everett*)

*O*ccasionally, there will come a cinematic moment that has nothing else to distinguish it beyond the simple beauty of a hunky guy wading naked in a swimming hole (!). These times come up so rarely, who could fault me for reprinting such a pristine pastoral?

this spread: ED HARRIS (*b.* November 28, 1950, Tenafly, New Jersey.) A two-time Oscar nominee, for *Apollo 13* (1995) and *The Truman Show* (1998), Harris is one of those infrequently named "thinking man" hunks—so called because his body of work is as well-regarded as his very manly body. This still, from the largely forgotten film *Knightriders* (1981), shows that what hair Harris may lack atop his head he makes up for—with little room to spare—on his perfect pecs and abdomen. We also get a nice teasing glimpse of tanline, too! (*Kobal*)

the following spread: A sexy sextet of stars that came to the fore in the eighties, including clockwise, from top left: MEL GIBSON (*b.* January 3, 1956, Peekskill, New York.) Gibson's family moved when he was twelve; from there on he acquired his "down-under" charm. Hot and hunky in just about everything, this still is from *The Bounty* (1984). (*Everett*) KEVIN COSTNER (*b.* January 18, 1955, Compton, California.) He became a star as the very touchable Eliot Ness in *The Untouchables* (1987) and showed off his butt in *Dances with Wolves* (1991). This pic is from *No Way Out* (1987). (*Everett*) ALEC BALDWIN (*b.* April 3, 1958, Amityville, New York.) This liberal-leaning, hairy hottie is easily the handsomest of the Baldwin boys, which includes Adam, Steven, and William. This scene is from *Miami Blues* (1990), though you can also catch his chest on display in *Working Girl* (1988). (*Everett*) PATRICK SWAYZE (*b.* August 18, 1954, Houston, Texas.) Swayze has had an up-and-down career, going from memorable highs and hits, such as *Dirty Dancing* (1987) and *Ghost* (1990) to this less-than-sterling effort, *Road House* (1989), whose only distinctions may be his body and the fact that he sings on the score. We love him for playing drag in *To Wong Foo, Thanks for Everything, Julie Newmar* (1996). (*Everett*) DENNIS QUAID (*b.* April 9, 1954, Houston.) Quaid had one of those great bodies that just seemed to slowly insinuate itself into many of his roles, regardless of whether its presence actually advanced the plot. Three examples: 1987's *Suspect* (okay, he gets slashed by a knife and has to remove his shirt!), 1990's *Postcards from the Edge* (dodging blank bullets in the street), and here in *Innerspace* (1987). (*Kobal*) WILLIAM HURT (*b.* March 20, 1950, Washington, D.C.) Stepson of Henry Luce III (of *Time* magazine), Hurt had the type of moderately developed body that would have been considered outstanding in another time. No doubt, too, because of the age we live in, the star of *Body Heat* (1981) has kept it in much better form than he may have otherwise. However, it seems we all end up winners! (*Everett*)

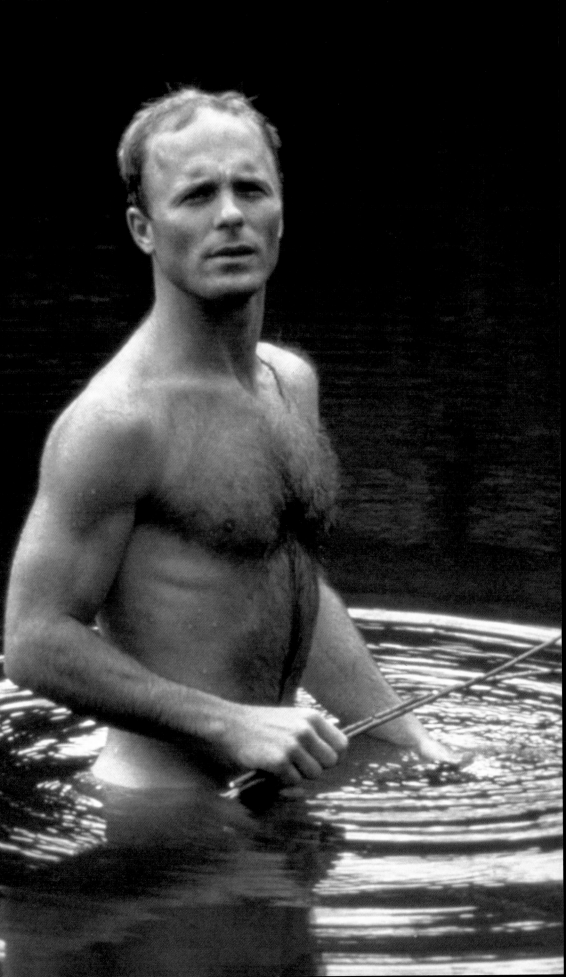

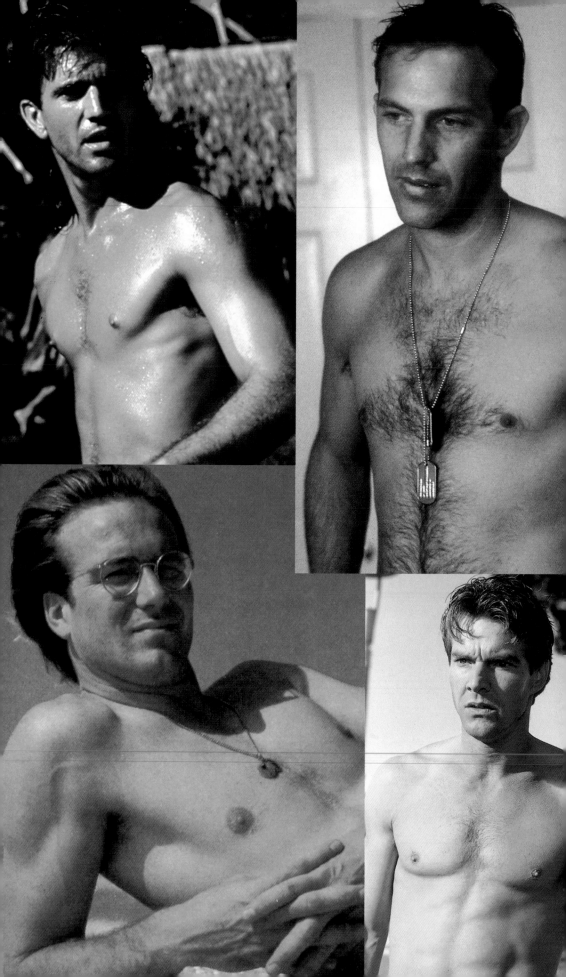

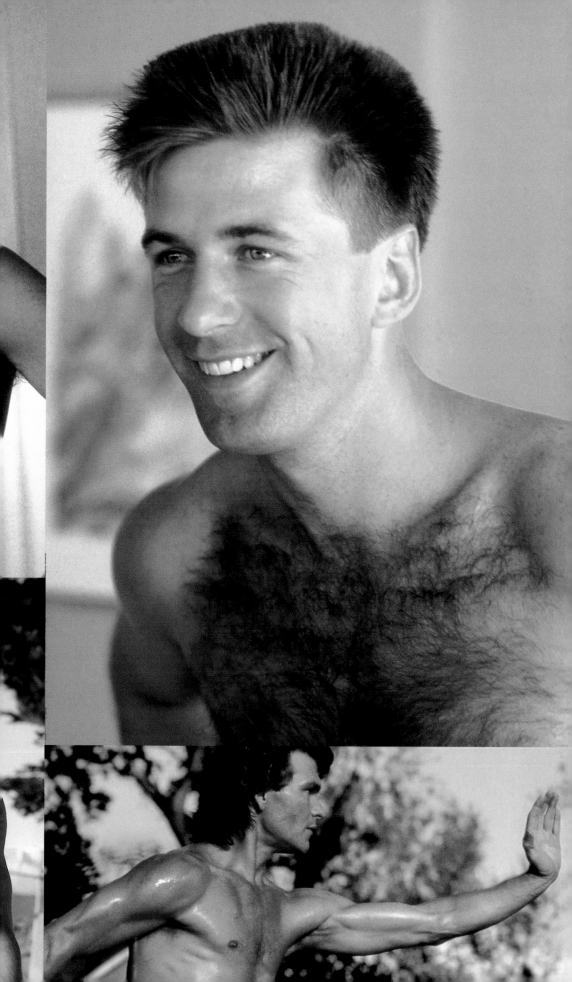

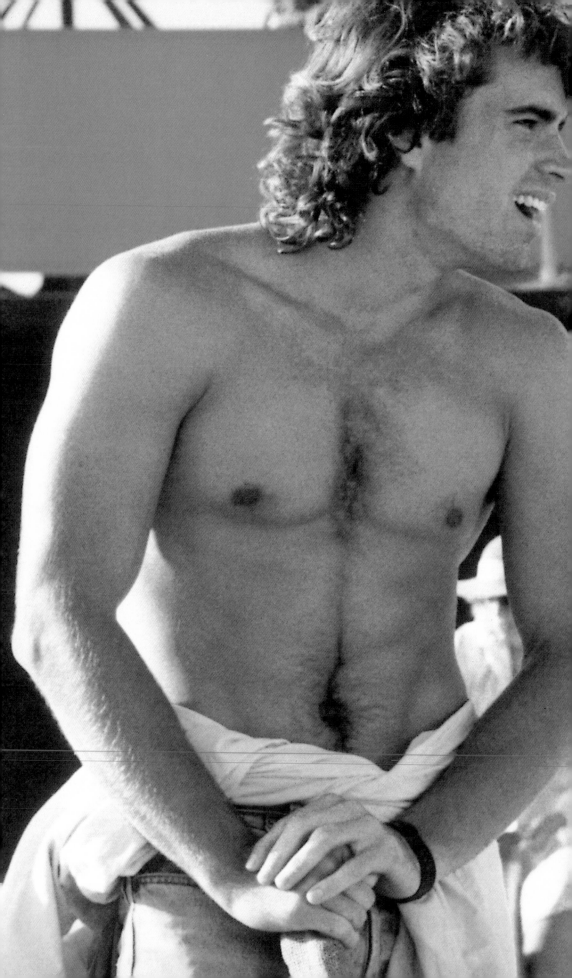

One last time to marvel at the muscle parade that was known as the eighties—again, mainly noteworthy in that the occurrence of sinewy splendor was still so unexpected. So much so that when you saw something as magnificent as these two bodies—left and below (my apologies to Mr. Corey Haim, at right, who did manage to get to the gym as he got a little bit older)—you could sense inaudible gasps of delight from audience members. Go on, admit it. You did it too.

this spread, left: JASON PATRIC (*b.* 1966, Queens, New York.) Son of playwright Jason Miller and grandson of Jackie Gleason, Patric appears in far fewer films than could ever satisfy his palpitating fans. Not to worry, if he did only one, *The Lost Boys* (1987) would be the perfect time capsule—if all you wanted to do is pick a film that showed him off in his (or nearly any man's) finest physical condition. What some of us wouldn't give to look like that in our (very) early twenties. He puts the "abs" in absolutely! (*Kobal*) *below:* STEVE GUTTENBERG (*b.* August 24, 1958, Brooklyn, New York.) Another pure "where did he get that body?" moment. When Guttenberg rose out of the water in *Cocoon* (1988), he did more than attract the amorous attentions of alien Tahnee Welch. His near-to-perfect pectorals and impossibly perfect tan transfixed the gaze of everyone sitting in darkened theaters *and* set a new standard for chest aficionados. (*Everett*)

THE NINETIES AND BEYOND:

MUSCLED MALE MAGNIFICENCE

Now that the shirt had been lifted off there would be no putting it back on. In the wake of the Reagan-Bush years, the Clinton White House brought with it the welcome acceptance of broader cultural diversity. The nineties male body became leaner, but more sculpted, younger, and less aggressive than its eighties form. It also represented a great deal of racial integration and sexual ambiguity—in an attempt to embrace this new age of tolerance.

this spread: RUPERT EVERETT (*b.* May 29, 1959, Norfolk, England.) A favorite pinup of the new "permissive" nineties—and the first openly gay male sex symbol. Interestingly, Everett rose to stardom in *Another Country* (1984), but not with the amazing body he possesses today. In fact, his nineties body was one of the more telling aspects of the last decade of the twentieth century. Compared with women, men always enjoyed a wider berth when it came to the physical shortcomings. But, in a trend that began in the eighties, maturer males were now competing for roles against younger gents with their talent *and* bodies. So, older male stars (post-twenties) hit the mats with a bang. (However, their resounding success has proved troublesome for the American male, once happy to grow older with grace.) (*Corbis-Outline*) *inset:* A sublime example of mature manliness, if there ever was one, would be JEFF BRIDGES (*b.* December 4, 1949, Los Angeles). His best thirty-something skin moment? *Starman* or *Against All Odds* (both 1984). His best near-fifty moment? The 1996 film *White Squall* (seen below), where he admirably holds his own against a group of guys half his age, including cutie Scott Wolf. (*Everett*)

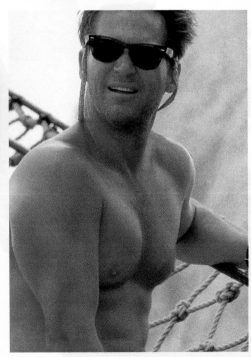

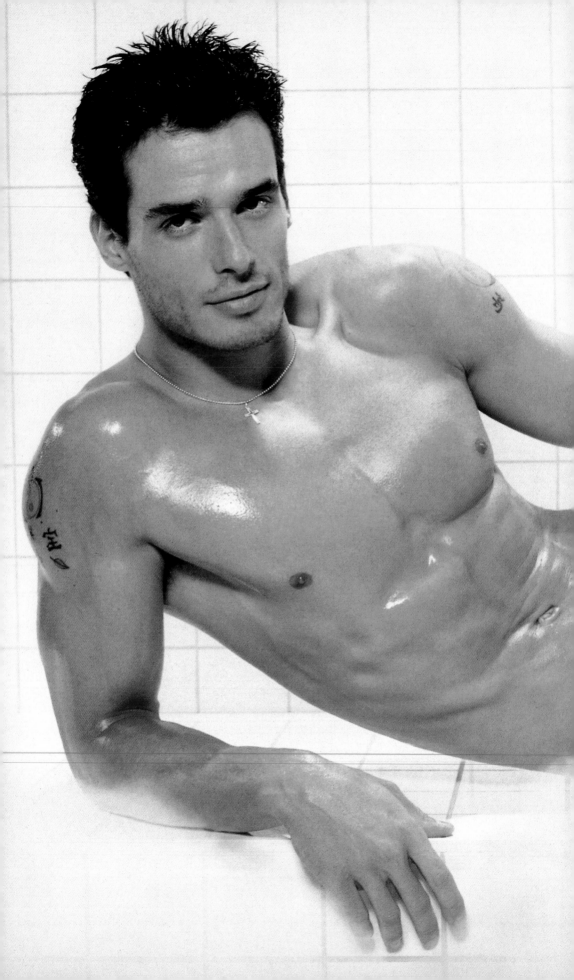

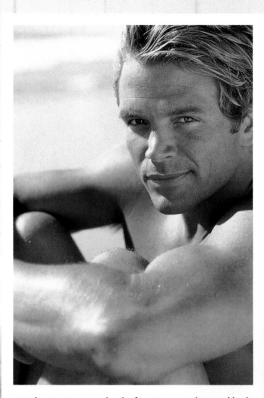

The nineties were also the first time our culture guiltlessly allowed for the unbridled enjoyment of a beautiful male body just because it was there—and for no other reason. Though many men are feeling the "pinch" of a society that has now directed its focus on a man's physique—the way it had long since lingered on a woman's—I dare say there is something quite breathtaking about a forty-foot-tall underwear-clad actor staring down out you from high atop a Times Square billboard. You go, Antonio!

this spread: ANTONIO SABATO JR. (*b.* February 29, 1972, Rome, Italy.) Has anyone ever seen a more perfect-looking male specimen? Okay, so he might not be your cup of tea (but just what exactly are you doing with this book, then?). Beyond his impossibly well-defined calf muscles (as well as everything else) Sabato is a thoroughly nice fellow—something that not all good-looking men can say about themselves. (*Kenneth Willardt/Corbis-Outline*) *inset:* DAViD CHOKACHi (*b.* David Al-Chokhachy, January 16, 1968, Plymouth, Massachusetts) is a member of the buffed-and-ready casts of *Baywatch*. Though it is still too early to tell, Chokachi may have the problem (!) of being too attractive for the good of his career. Viewers don't tune in to see him *in* character, they want to see him *out* of his clothes—as often as possible. This is a dilemma many too-handsome actors have faced from the beginning: the inability of getting the audience (and those who sit on the casting couch) to see past their bodies. (*Kobal*)

137

The nineties saw the emergence of many types of films that marketed themselves to specific members of the moviegoing audience, differing greatly from the generalized target demographics of the eighties. This narrower focus allowed film content to better reflect the diversity of our culture—both philosophically *and* physically. Now there were films catering directly to African-American, gay, senior, Hispanic, female, and teen moviegoers. Though big-budget epics still found favor among the majority of patrons, many of them offered more realistic circumstances. As far as the male body was concerned, the general consensus was the same across the board: beautiful bodies, everywhere, for every taste.

inset: LEONARDO DiCAPRIO (*b.* November 11, 1974, Los Angeles.) In the action-adventure category, DiCaprio brought back the South Seas island tale with *The Beach* (2000). But even with his pumped body, DiCaprio found it hard to command the same throngs that had visited him for the mega-hit *Titanic* (1997). (*Kobal*) *this spread:* Another reliable action-adventure genre, the war movie, saw new life in the late nineties, with two much-heralded offerings: *Saving Private Ryan* (1998) and *The Thin Red Line* (shown here, 1998). Both also had male casts bursting at the seams with muscle, including this fine soldier, JIM CAVIEZEL (*b.* September 26, 1968, Mt. Vernon, Washington), who also starred in the recent guy flick *Frequency* (2000). (*Kobal*)

In the category of good-looking guys behaving very badly, the last few years have seen a proliferation of pretty poison. Unfortunately, it's so hard for those waiting for the "male" to resist temptation if the package delivered to your door is so nicely wrapped.

this spread: JUDE LAW (b. December 29, 1972, London.) In the beautiful-but-bad corner, Law has few contemporary peers (the closest I could conjure is George Sanders, though Law is far more svelte). And—like Sanders—his sinister edge only makes him more attractive. Even though he seems to exude evil out of every pore, you don't mind it as much coming from that fab physique. A dashing devil who gets his comeuppance from obsessed Matt Damon—in an equally evil role—but not before he gets to strut his stuff in *The Talented Mr. Ripley* (1999). (*Kobal*) *below: CHRISTIAN BALE* (b. January 30, 1974, Pembrokeshire, Wales) has a film career with little of the same aura that pervades Law's tyrannical turns for the camera, but that hasn't stopped this gifted actor from cutting loose in *American Psycho* (2000). But what astounds most viewers—beyond the mayhem—is Bale's exquisitely cut-glass body (possibly the most perfect ever seen on film). Not surprisingly, Bale said it was almost too painful to get it in such chiseled condition. Thank goodness! Could you deal with it if he just looked that good naked, naturally? (*Everett*)

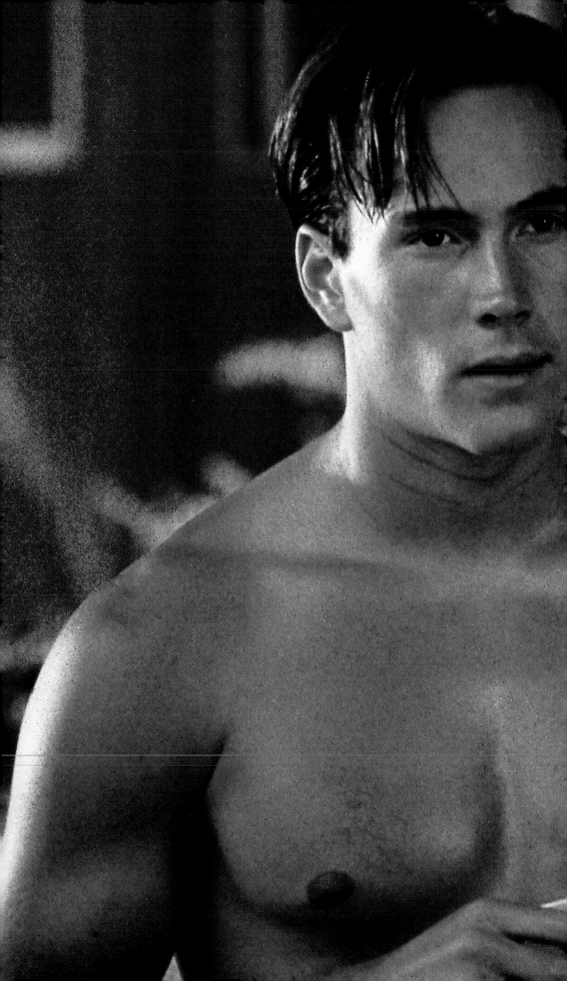

For body-watchers, the most likely place to catch a glimpse of a too-hot torso is the ever-popular teen flick. A viable category since the late fifties, it has been only recently that the genre has earned the respect of the film industry. Why? Because of the over one-billion-dollar take for the film *Titanic* (1997), which has been partially credited to the box office appeal of Leonardo DiCaprio (see page 138). His audience? Teenaged girls (and their beaux). Once Tinseltown determined that registers were ringing because of that rosy-cheeked rogue, they quickly began inundating the market with more date movies. Despite the cookie-cutter content of most of these flicks, plenty of tasty actors are stirred into the mix to satisfy every appetite.

inset: RYAN PHiLLiPPE (*b.* September 10, 1974, New Castle, Delaware.) Young Phillippe has become a natural at playing the rapscallion. Though he may not please your mother, his company is surely the guarantee of a good time. Absolutely delectable in *54* (1998). (*Photofest*) Then, there is the type of boy your mother dreams will show up at the front door. *this spread:* CHRiS KLEiN (*b.* March 14, 1979, Hinsdale, Illinois.) Enter this heavenly stud, who has made waves so formidable since his debut in *Election* (1999) that all of Hollywood is looking to get wet. Fortunately, Mr. *American Pie* (1999) is *Here on Earth* (2000) for all to adore (as seen here). How do you get a body like that, at his age? (*Photofest*)

143

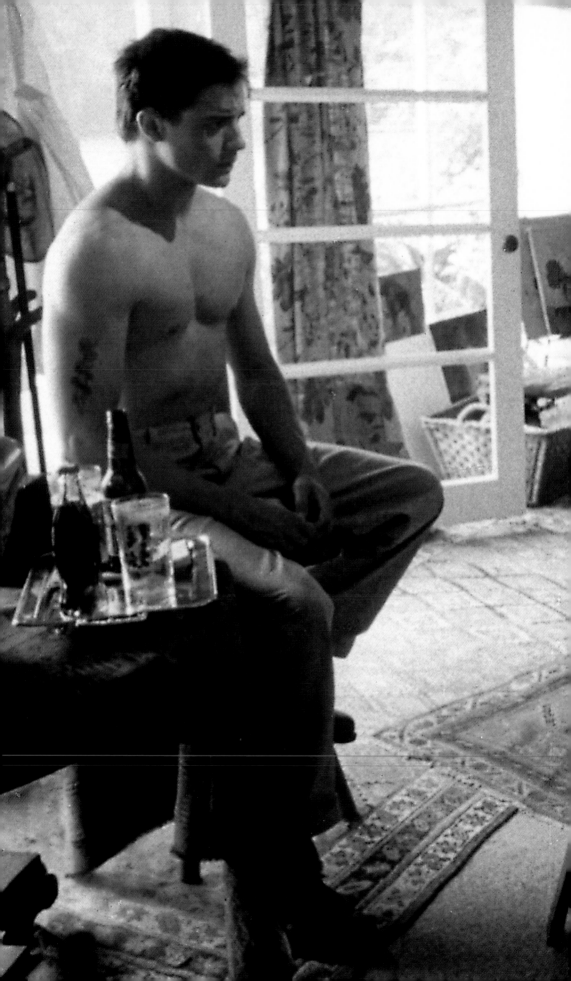

Films enjoyed by predominantly gay audiences have been in existence for quite some time (not counting gay pornography) and go back at least to the screen adaptation of the 1970 serio-comedy *Boys in the Band* (or you could count every Judy Garland movie ever made!). But even so, *Boys* was not produced exclusively for gay men—too much of a financial risk. Even the acclaimed 1998 film *Gods and Monsters* was not marketed to a specific audience—though one could argue the point with that nude swimming-pool scene!—but owed much of its success to gay filmgoers. Still, Hollywood has finally come to appreciate the power of the gay dollar, and the manufacture of product to please our palates is in full swing. Historically, since gay men are notorious for their love of the male body (duh!), these films are brimming over with six-pack abs, rock-hard pecs, and tight tushes. If one ever wants to see a glimpse of the ideal male body, a side trip to the gay film section of your local video store will bring you fast and satisfying results. Pounce!

left: BRENDAN FRASER (b. December 3, 1968, Indianapolis, Indiana.) Here, accompanied by snow-white-haired gay hero Ian McKellen, Fraser was perfect for the role of the not-as-dense-as-he-looks landscaper in *Gods and Monsters*. With that marvelously muscular build, who would not want him around to water your lawn? Fraser also seems to have a lot to swing with in *George of the Jungle* (1997), the film that put him in the one-hundred-million-dollar movie club. (*Photofest*)

MAN TO MAN:
A BEEFY FEAST

It's not always fair to compare one man's body to another's—the circumstances in which they appear are never equal. However, there are some interesting and compelling reasons to do so.

Historically, with the exception of the "Latin lover" stereotype, mainstream film studios have treated men of color with a distinct lack of sensitivity, understanding—and recognition. (Unfortunately, even *Shirtless!* reflects the "invisibility" of non-white actors.) When it came time to display these men's bodies, the context was typically belittling to say the least. Undressed black men were slaves, prisoners, or jungle natives, and Asian men were rail workers, field hands, or island natives. Since their bodies were regarded as savage and wanton, these characters almost never appeared unclothed under normal circumstances.

It was not until the mid-fifties, when Harry Belafonte became an international sensation that the sight of a barechested black man was tolerated (yet still on the level of a subordinate) by white mainstream audiences. (Incidentally, though Sidney Poitier was often shirtless, his chaste character made him less of a sexual threat than Belafonte—and allowed him to work far more.) It was not until the late sixties (see page 93) that black men began to exert themselves physically *and* sexually onscreen. Now, in the new millennium, black audiences have a discernible piece of the box office pie and are filling it with choice ingredients.

Unfortunately, Asian men have had an even more exasperating time. For the most part white moviemakers have long considered them a negligible part of the demographic landscape. With the exception of Bruce Lee, no Asian male has risen above the field. Recently, though, undeniable heartthrobs like Jason Scott Lee (no relation) are making dents along the surface. Only time will tell how far high he will climb.

left: *JAMIE FOXX* (b. December 13, 1967, Terrell, Texas) struts his ample stuff in *Any Given Sunday* (1999). Foxx, known for his comedic talents, is no joke when it comes to his gorgeous body. (*Kobal*) inset, above: *HARRY BELAFONTE* (b. March 1, 1927, Harlem, New York), shown here in *Island in the Sun* (1957), was the first black personality considered a "mainstream" sex symbol. (*Everett*) inset, below: *BRUCE LEE* (see also page 112) can be considered the first mainstream Asian male sex symbol. (*Photofest*) inset, below right: *JASON SCOTT LEE* (b. November 19, 1966, Los Angeles) played Bruce Lee in the biopic *Dragon* (1993) and has continued playing major parts in high-profile productions ever since. (*Everett*)

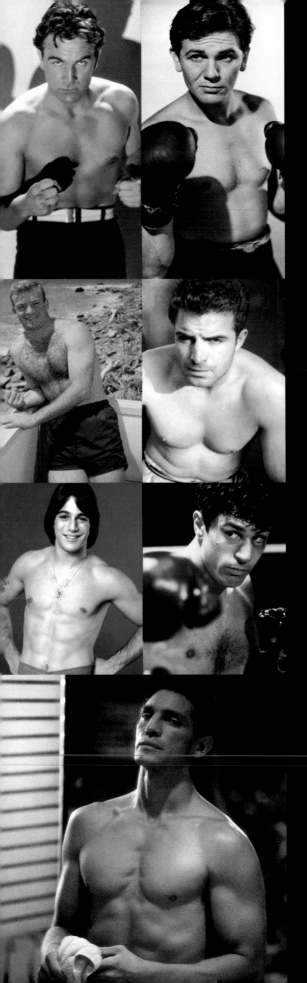

Throughout the century, the pugilist came up so often I thought it interesting to place as many of them a possible together. For the fight-minded fancier, in chrono logical order (starting from top left to right): HENRY WILCOXON (b. September 8, 1905, Dominica, Wes Indies), a super hunk as Marc Antony in *Cleopatra* (1934 (*Kobal*); JOHN GARFIELD (b. Julius Garfinkle, March 4, 1913, New York City. d. 1952), memorable and muscu lar in *Body and Soul* (1947), which netted him an Oscar nod (*Everett*); ALDO RAY (b. Aldo DaRe, September 15, 1925, Pen Argyl, Pennsylvania. d. 1991), all military might in *Battle Cry* (1955) (*Kobal*); VINCE EDWARDS (b. July 9, 1928, New York City), televi sion's brooding *Dr. Ben Casey* (*Michael Ochs*); TONY DANZA (b. Antonio Iadanza, April 21, 1951, Brooklyn New York City), as toned Tony Banta, a part-time boxer/cabbie, in TV's *Taxi* (*Michael Ochs*); ROBERT DENIRO (b. August 17, 1943, New York City), Oscar winner for his powerhouse portrayal of Jake LaMotta in *Raging Bull* (1980) (*Everett*); and ERIC ROBERTS (b. April 18, 1956, Biloxi, Mississippi), older brother of Julia Oscar nominee for *Runaway Train* (1985), and savagely sexy in *Star 80* (1983) and gay-friendly in *It's My Party* (1997). (*Everett*)

above right, from left: The "Latin lover" type has seen some pleasant changes over the the years: FERNANDO LAMAS (b. January 9, 1915, Buenos Aires. d. 1982) the dashing dad of Lorenzo, who was *Dangerous Wher Wet* (1953) (*Corbis*); ERIK ESTRADA (see also page 111) who took the seventies for a spin on his Harley— and us into heaven with his tantalizingly tight officer's uni form (*MPTV*); and, entering this century very nicely indeed, with his gorgeous body (and talent), BEN JAMIN BRATT (b. December 16, 1963, San Francis co), who has bared all on TV's *NYPD Blue* and just enough (is that possible?) in *The Next Best Thing* (2000). (*Isabel Snyder/Corbis-Outline*)

middle right, clockwise: If the spy who loved me looked anything like these three gents, no secret would be safe SEAN CONNERY (see also pages 90–91) the undis puted leader of the "Bond" pack (*Everett*); ROGER MOORE (b. October 14, 1927, London), the unexpect edly beefy Brit—more *The Saint* than the sinner—who ruled longest in the role (1973–85) (*David Sutton/MPTV*) and PIERCE BROSNAN (b. May 16, 1951, County Meath, Ireland), the recent, "Steele-y" inheritor of the crown. (*Camp/Corbis-Outline*)

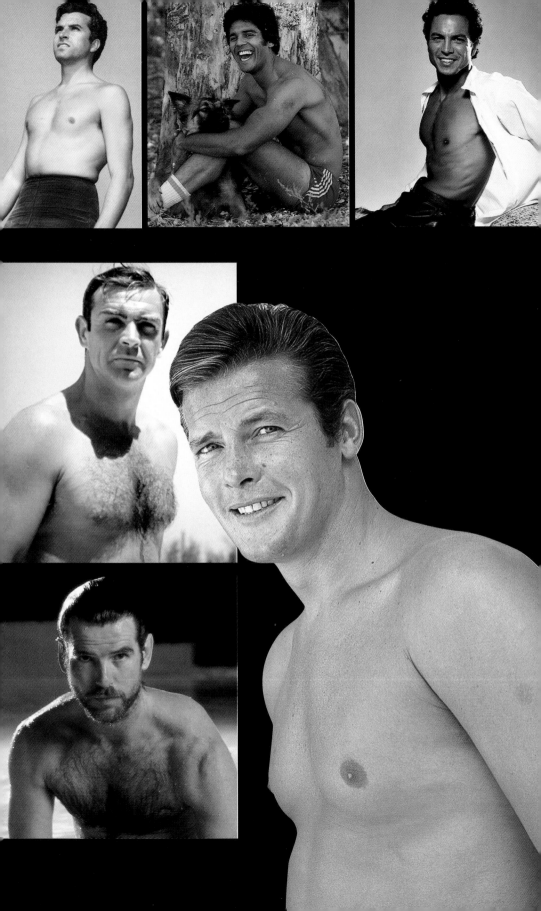

There are two ways you can look at the Hollywood male body over the course of the last century: how much it has changed and how much it has stayed the same. Here are three comparisons:

this page: the barrel chest and abdomen of the fifties on **STEWART GRANGER** (*b.* James Stewart, May 6, 1913, London. *d.* 1993) from *King Solomon's Mines* (1950) (*Kobal*) vs. the ripped-and-cut version of the nineties on **MARK WAHLBERG** (*b.* June 5, 1971, Dorchester, Massachusetts), during his underwear-modeling days. Is there any question who gets the prize? (*Corbis/LGI*) *far right, above:* sleek and slim fifties babe, à la **MONTGOMERY CLIFT** (*b.* October 17, 1920, Omaha, Nebraska. *d.* 1966) seen here in *From Here to Eternity* (1953) (*Photofest*) vs. sleek and slim nineties babe à la **BRAD PiTT** (*b.* December 18, 1963, Shawnee, Oklahoma) seen here in *The Fight Club* (1999). (*Kobal*) *far right, bottom:* father vs. son, with a no-contest pairing of tightly packed **PATRiCK WAYNE** (*b.* July 15, 1939, Los Angeles) (*Corbis*) against his doughy dad **jOHN WAYNE** (*b.* Marion Michael Morrison, May 26, 1907, Winterset, Iowa. *d.* 1979) Sorry, Duke! (*Kobal*)

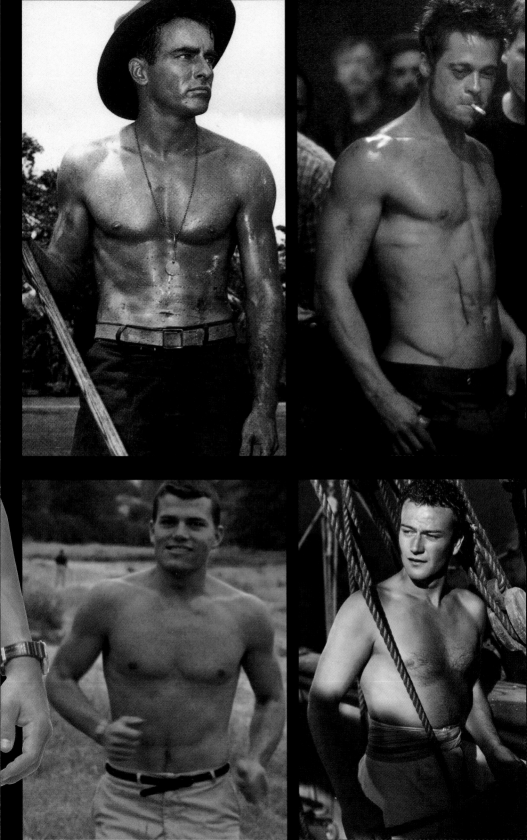

Muscle to muscle, the two "biggest" stars of them all: *SCHWARZENEGGER* (see also page 117) and *REEVES* (see also page 60). If this were a vote and came down to stuffing ballots in a box, I'd put all mine in Reeves's briefs. (*Author's collection/Everett*)

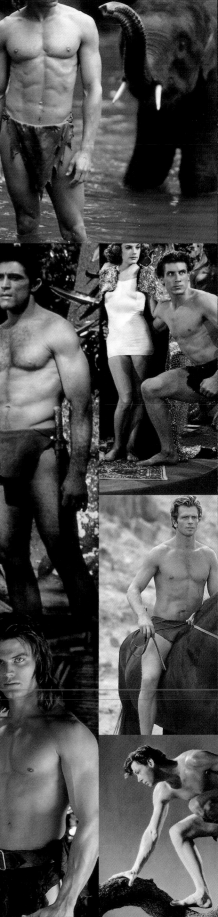

No series of films has given shirtless-men seekers more to gape at than the ape-man himself, Tarzan. *clockwise, from far left:* MILES O'KEEFE, in the naughtiest version of all (*Tarzan the Ape Man*, 1981) (*Kobal*); LEX BARKER, the most movie star handsome (*Tarzan's Magic Fountain*, 1949) (*Kobal*); the Disney animated *Tarzan* (1998), who's almost too well-defined for words (*Kobal*); BRUCE BENNETT, a sexy interloper (*Tarzan and the Green Goddess*, 1938) (*Kobal*); GORDON SCOTT, the sexiest (in my opinion) from *Tarzan's Hidden Jungle* (1955) (*Photofest*); the "king of swing" himself, JOHNNY WEISSMULLER (*Tarzan the Ape Man*, 1932) (*Photofest*); CASPER VAN DIEN, bad hair, excellent body in the recent 1999 installment (*Kobal*); hairy and oh-so-hot, MIKE HENRY (*Tarzan and the Valley of Gold*, 1966) (*Kobal*); a forgotten jungle Jim, GLENN MORRIS (*Tarzan's Revenge*, 1938) (*Kobal*); and for the small screen, massive RON ELY (*MPTV*). *right:* DENNY MILLER (*Tarzan the Ape Man*, 1959) too beach boy to feel at home in the bush. (*Kobal*)

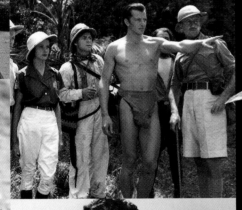

C ould anyone pick between these two? Arguably, the best bodies ever seen on film (or anywhere, for that matter). *left:* ¡OHNATHAN SCHAECH (see also page 2) (*Staedler/Corbis-Outline*); *right:* PAUL NEW-MAN (see also page 80) (*Globe*). Wouldn't it be great if all of life's decisions were this rock-hard? While you're thinking, here are some lists to ponder:

MOViES

It Happened One Night (1934)
 Gable goes shirtless!
A Streetcar Named Desire (1951)
 Brando bares all!
Picnic (1955)
 Holden holds up—quite well!
Ben-Hur (1959)
 It's toga time!
Sweet Bird of Youth (1962)
 Newman gets paid for it!
Dr. No (1962)
 Mr. Yes! a.k.a. Sean Connery
Romeo and Juliet (1968)
 A dude's derriere on display!
Saturday Night Fever (1977)
 Mirror, mirror, on the wall!
American Gigolo (1980)
 Call me anytime, Richard Gere
Thelma and Louise (1992)
 Time to make a Pitt stop!

DATES

1915 Francis X. Bushman, named
 first male matinee idol
1934–68 The censorship Code takes
 all the fun out of film
1939–45 World War II; USA ships
 the beef over land, sea, and air
1957 Elvis Presley shakes things up
 on Ed Sullivan
1959–60 Eisenhower to Kennedy—
 from "daddy" to "Daddy-O!"
1963 Legalization of "nude" mail
 lets you see the male
1968 Instigation of MPAA ratings sets
 the tone
1971 Burt Reynolds in *Playgirl* lets
 (almost) all of it hang out
1979–80 Carter to Reagan—from
 boogie nights to unhappy days
1992–93 Bush to Clinton—from the
 Dark Ages into de-light!

TV SERiES

General Hospital
Route 66
Wild, Wild West
Man from Atlantis
Dynasty
Miami Vice
Melrose Place
Saved by the Bell
Baywatch
Dawson's Creek

MEN

George O'Brien
Guy Madison
Victor Mature
Marlon Brando
Tab Hunter
Paul Newman
Steve Reeves
Sean Connery
Arnold Schwarzenegger
Brad Pitt

MIA (MISSING IN ACTION)

Francis X. Bushman
Georges Brueggemann
Joel McCrea
Lyle Waggoner
Robert Redford
Patrick Duffy

Maxwell Caulfield
Bruce Willis
Denzel Washington
Guy Pearce
Keanu Reeves
Taye Diggs

iNDEX:

A HARD MAN IS EASY TO FIND

Aames, Willie..126
Adams, Nick...78
Anderson, Richard Dean.......................................106
Albert, Edward...107
Atkins, Christopher..10
Avalon, Frankie...76
Baio, Scott..98
Baldwin, Alec..131
Bale, Christian..140
Barker, Lex..153
Barrymore, John..14-15
Belafonte, Harry...147
Bennett, Bruce...153
Benson, Robby...95
Boone, Pat..77
Brady, Scott..48-49
Brando, Marlon..42
Bratt, Benjamin..149
Bridges, Jeff..135
Brosnan, Pierce..149
Brown, Jim..93
Brynner, Yul..57
Caan, James...114-15
Cassidy, Shaun..94
Caviezel, Jim..136-37
Chamberlain, Richard..71
Chandler, Jeff..41
Chokachi, David..137
Clift, Montgomery..151
Connery, Sean..90-91, 149
Conrad, Robert...84-85
Cooper, Gary..25
Costner, Kevin...130
Curtis, Tony..53
Damon, Mark...68-69
Danton, Ray..160
Danza, Tony..148
Dean, James..40-41
DeNiro, Robert...148
Derek, John..56-57
DiCaprio, Leonardo...136
Dillon, Matt...................................108-109, back endpaper
Donahue, Troy..74-75
Douglas, Kirk..38-39
Eastwood, Clint.....................................front endpaper, 83
Edwards, Vince...148
Egan, Richard..54-55
Elliott, Sam...103
Ely, Ron..152
Ericson, John...49
Estrada, Erik...111, 147
Everett, Rupert...134-35
Evigan, Greg...101
Fabian..70-71
Fairbanks, Douglas..12
Fairbanks Jr., Douglas..20
Farrell, Charles..14
Flynn, Errol..28
Foxx, Jamie...146-47
Fraser, Brendan...144-45
Gable, Clark..26-27
Garfield, John...148
Gere, Richard......................................122-23, back cover
Gibson, Mel..130
Gilbert, John..20-21
Granger, Stewart...150
Grant, Cary..118
Guttenberg, Steve..133
Hall, Jon...24
Hamilton, George..75
Harmon, Mark...126
Harris, Ed...128-29
Harrison, Gregory...10
Henry, Mike..152
Heston, Charlton...56-57
Hexum, Jon-Eric..125
Hinwood, Peter...156
Holden, William...44-45
Horne, Geoffrey..8
Hudson, Rock..6-7
Hunter, Jeffrey...54
Hunter, Tab......................................front cover, 50-51
Hurt, William..130
Klein, Chris...142-43
Ladd, Alan...32-33
Lamas, Fernando..149
Lamas, Lorenzo...124
Lancaster, Burt...38

Landon, Michael...86
Law, Jude...140-41
Lee, Bruce...112-113, 147
Lee, Jason Scott...147
Lowe, Rob...123
Lundgren, Dolph...120-21
MacArthur, James..66-67
MacMurray, Fred...29
Madison, Guy...9, 31
Maharis, George..82-83
Matheson, Tim..100
Mature, Victor..32
McNichol, Jimmy...99
Miller, Denny..153
Mineo, Sal..1
Mitchum, Robert...34
Montalban, Ricardo...46-47
Moore, Roger...149
Morris, Glenn..152
Muni, Paul..22
Murphy, Audie..30-31
Nader, George..62-63
Newman, Paul...80-81, 155
Norris, Chuck..113
Novarro, Ramon..17
O'Brian, Hugh..64-65
O'Brien, George...9, 16
O'Keefe, Miles...152
O'Neal, Ryan..11
Patric, Jason..132-33
Payne, John..4-5
Perkins, Anthony...78-79
Phillippe, Ryan..143
Pitt, Brad...151
Power, Tyrone...36
Quaid, Dennis..130
Ray, Aldo..148
Reagan, Ronald..35
Reeve, Christopher..118-19
Reeves, Steve...60-61, 152
Reynolds, Burt..104-105
Roberts, Eric..148
Robertson, Cliff...72-73
Robeson, Paul...23
Sabato Jr., Antonio......................................136-37
Sabu..37
Saxon, John..158-59
Schaech, Johnathan...2-3, 154
Schneider, John..126
Schwarzenegger, Arnold.....................................116-17, 152
Scott, Gordon..153
Scott, Randolph..18-19
Selleck, Tom...127
Sheen, Martin..107
Smith, Rex...102
South Pacific (members of the male cast of)..................58-59
Stallone, Sylvester..116
Stevenson, Parker...102-103
Swayze, Patrick..131
Taylor, Rod..88-89
Thomas, Philip Michael...126
Todd, Richard..157
Travolta, John...118
Urich, Robert..110
Valentino, Rudolph.......................................12-13
Van Dien, Casper...152
Vincent, Jan-Michael..94-95
Voight, Jon...92
Wagner, Jack...120
Wagner, Robert..52-53
Wahlberg, Mark...150
Walker, Clint..86-87
Wayne, John..151
Wayne, Patrick...151
Weissmuller, Johnny..152
Whiting, Leonard...92-93
Wilcoxon, Henry..148

left: **PETER HiNWOOD** (b. May 17, 19??) was the big payoff in *The Rocky Horror Picture Show* (1975). A top seventies model, Hinwood had his ten minutes of movie fame—have you ever seen a better display of gold lamé?—then became an antiques dealer. (*MPTV*) *right*: **RiCHARD TODD** (b. June 11, 1919, Dublin.) A parachutist during the Second World War, Todd landed in the big time—and an Oscar nod—with one of his first films, *The Hasty Heart* (1949). (*Kobal*)

ACKNOWLEDGMENTS:

BEHIND EVERY MAN . . .

. . . are a lot of people who make his work look very good, indeed. Therefore, the humble author would like to thank:

My new editor at **Universe**, Chris Steighner, whose appearance was a gift from the gods of publishing (it didn't hurt that we both liked the topic, either!). To Charles, Bonnie, John B., John D., et al., for making this as easy an undertaking as was humanly possible. I still don't know how you guys do it.

Thanks to Joe and Dan, Tony, Miisa, Lee and kids. To Teresa and Ward. To Mark, Darlene and John, Peter and John, Chris, Jim and Gary, Mitch and Harris, Mike and Chris, Wayne and Kenny, Leon, Vicky, Abby, and Joyce. To mom, Jan and Tom, Prescott, dad, and Len (for still claiming me as one of their own). To Dan O., for wrestling with my crazy year and still ending up a friend. To Kevyn, for being so incredibly supportive these last few months. To Geoffrey Beene, for being the single most important influence on my work. To Red, for being around and keeping things light. And finally to Robert, to whom I never give enough compliments when he goes shirtless, and for allowing me to walk around the house as though I don't own a clean T-shirt. For you, I will always give the shirt off my back.

I'd also like to give what's left of my wardrobe to this next group of amazingly generous and caring people. To Bob Cosenza, Margie Steinmann, and Phil Moad (whose love for the subject matter resulted in a beefy boon for me), and the staff at **Kobal**. To Norman Curry, Donna Daley, Laurie Lion, Sean Spencer, and the gang at **Corbis**. To Meryl Rodney, Glen Bradie, and the troops at **Everett**. To my pals Yen Graney and Sid Avery at **MPTV**. To Howard Mendelbaum and his hunk headquarters at **Photofest**. To Jonathan, Helen, et al. down by the sea at **Michael Ochs**. To Sunni at **Globe**. To Mark Kerrigan at **Celebrity Services**. I also want to extend a special bit of thanks to the amazing guys and gals at **Emerging Image** for masterfully recreating the original splendor of many of these forgotten images—these gentlemen never looked so good.

this spread: JOHN SAXON (b. Carmen Orrico, August 5, 1935, Brooklyn). A strapping specimen of manhood in *The Reluctant Debutante* (1958). (*Corbis*) *closing page: RAY DANTON* (b. September 19, 1931, New York City. d. 1992). Talk about suggestive pictures! Danton, who dyed his hair jet black for films, played the title role in the 1960 movie *The Rise and Fall of Legs Diamond*. (*Kobal*) *closing endpaper: MATT DILLON* (see pages 108–09) (*Michael Ochs*) *back cover: RICHARD GERE* (see pages 122–23) (*Kobal*)

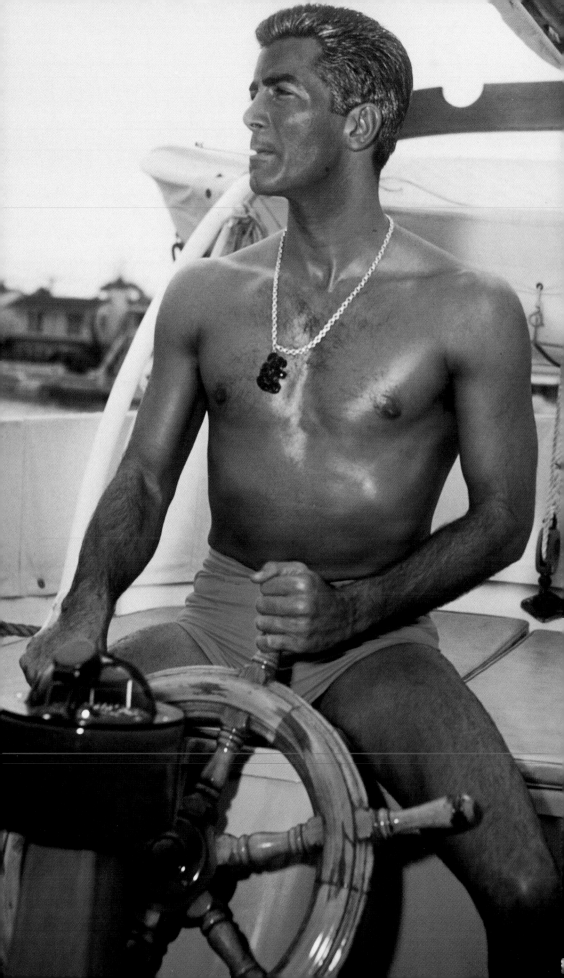

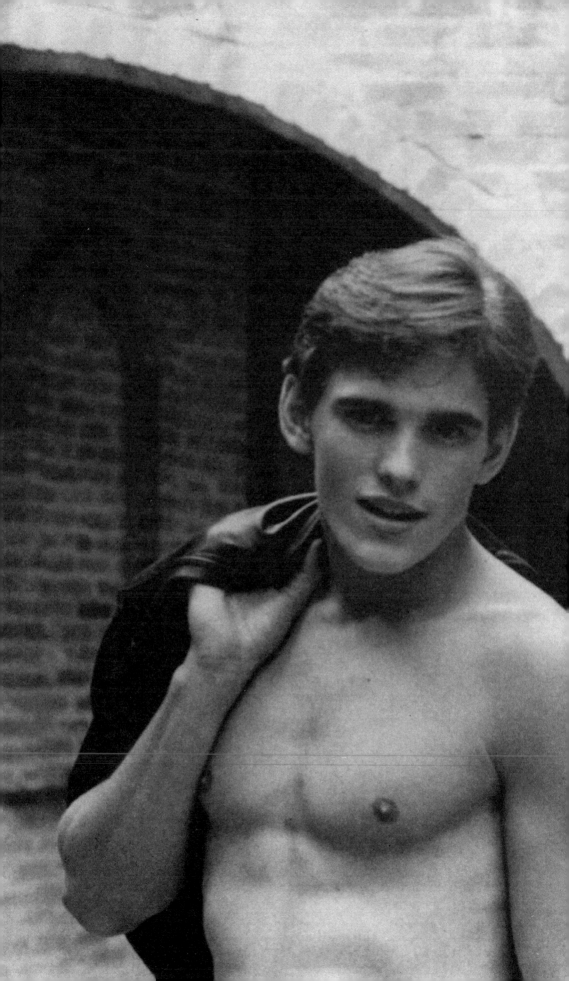